THE SCHOOL
OF PHOTOGRAPHY
BEGINNER'S GUIDE

First published in Great Britain in 2018
by The School of Photography

This edition published in 2024
by Ilex, an imprint of
Octopus Publishing Group
Carmelite House
50 Victoria Embankment
London, EC4Y 0DZ
www.octopusbooks.co.uk
www.octopusbooksusa.com

An Hachette UK Company
www.hachette.co.uk

The authorized representative in the
EEA is Hachette Ireland, 8 Castlecourt
Centre, Dublin 15, D15 XTP3, Ireland
(email: info@hbgi.ie)

Publisher: Alison Starling
Commissioning Editor: Richard Collins
Managing Editor: Rachel Silverlight
Editorial Assistant: Jeannie Stanley
Art Director: Ben Gardiner
Layout: Chris Robinson
Senior Production Manager: Peter Hunt

ISBN 978-1-78157-908-4

A CIP catalogue record for this book is
available from the British Library

Printed and bound in China

10 9 8 7 6 5

MIX
Paper | Supporting
responsible forestry
FSC
www.fsc.org
FSC® C008047

THE SCHOOL
OF PHOTOGRAPHY
BEGINNER'S GUIDE

ilex **MARC NEWTON**

Contents

1

Introduction
to photography

Introduction to photography

Hello and welcome to The School of Photography. I'm Marc Newton and in this book we are going to learn about the art and science of photography.

Before we begin, I'll just tell you briefly how this book works. *Complete Guide to Photography* is divided into chapters with accompanying tasks for you to complete.

You're going to need a notebook, so make sure you keep one to hand as we go through the book. As you learn photography, you make mistakes along the way. We all learn from our failures and your notebook is there to note down every time you do something wrong. What's really important is to know how to correct those wrongs. That is how we learn, and here's where I come in.

I will teach you the art and craft of photography, so that when you make a mistake, you'll know how to correct it. And after a bit of practice, you'll never make those same mistakes again. So remember, it's okay to make mistakes – it doesn't mean you've failed or it's too complicated for you.

That mistake has just given you a new opportunity to learn.

I'm going to start off by asking you this one question:

What is photography?
Grab your notebook and write down some answers.

I hope you have lots of things written down – it's an open-ended question with lots of different answers.

Common answers are:

Answer

- It's an art form
- It captures memories
- It records history
- It's a way of capturing a scene

Of course, it's all of these things, but essentially photography is the capturing of light.

Photography is a science; it was invented by scientists, not artists. You need to learn the science, or craft, of photography first, then you can get creative with that knowledge.

You might get that lucky shot, but you won't be able to be consistently good or consistently creative without that full control over the science of photography.

The craft of photography has been the same since its invention in the 1830s and it will continue to be the same forever.

This is because it's a science – it's the laws of physics at work.

It's essentially about capturing light beams.

1830

1890

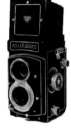

1930

1975

2020

This is a camera obscura, the most basic form of a camera. Light travels through the lens at the front and hits an imaging plane – in this case, a piece of tracing paper. This creates an image.

This, essentially, is photography.

Above: **You focus the image by moving the smaller box in and out of the larger box.**

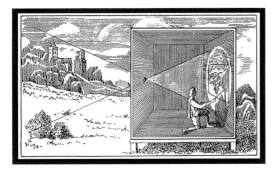
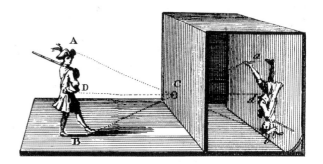

Camera obscuras have been around for hundreds of years, but no one could capture the image they saw.

It wasn't until the 19th century when this was able to happen.

Now we'll look at some old photographs to show how photography has essentially stayed the same for many years.

This photo from 1908 shows a young girl in a factory. The photo is blurred in the background, which is an effect called shallow depth of field. To get this effect, you need to use a wide aperture.

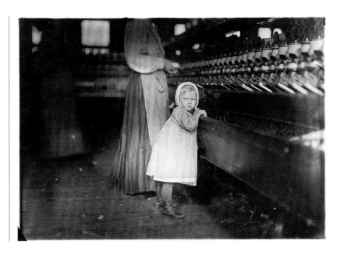

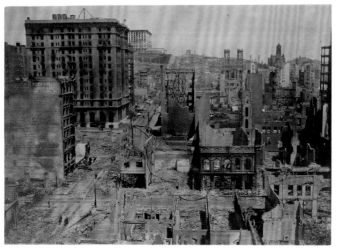

This photo was taken after the San Francisco earthquake in 1906. The foreground and background are sharp and this is an effect called long depth of field. To get this effect, you need to use a small aperture.

This photo from 1912 shows a shallow depth of field again, yet the boy on the left is blurred. This is because he was moving while the picture was taken. This is caused by using a slow shutter speed.

These old photos show that the capture of light was the same all those years ago. Depth of field is controlled by the aperture, and movement is controlled by the shutter speed. The principle has always stayed the same: light travels through a lens and is captured on an image plane.

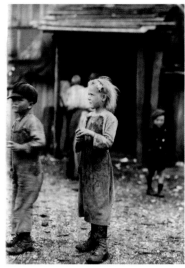
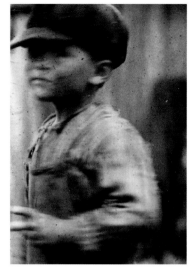

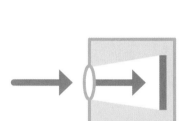

Above: **Blur from use of a slow shutter speed.**
Left: The oldest surviving photo ever taken — **'View from the Window at Le Gras'.**

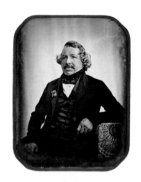

1

2

3

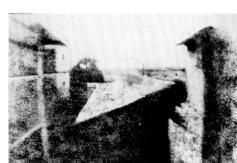

4

When photography was first invented, light was captured onto metal [1] and paper.

Then it was glass [2], then came plastic film [3] and now it is a digital chip [4] , but the process of light beams travelling through a lens and being captured has been the same and will continue to be the same.

It's for these reasons that we only use the manual settings in this book. This is so we learn to control aperture, shutter speed, ISO and so on.

Most modern settings on cameras are just gimmicks. They are selling points from the manufacturer and actually make things more confusing.

So, we'll use just the manual settings. Not only does this allow us to take control, it also allows us to understand what mistakes have been made. And like I said before, once you understand those mistakes, you can correct them very easily.

That is learning!

Introduction to photography

Camera kits & essential equipment

Types of camera

There are four main types of cameras that you can buy for general use:

- Compact
- Bridge
- Mirrorless
- DSLR

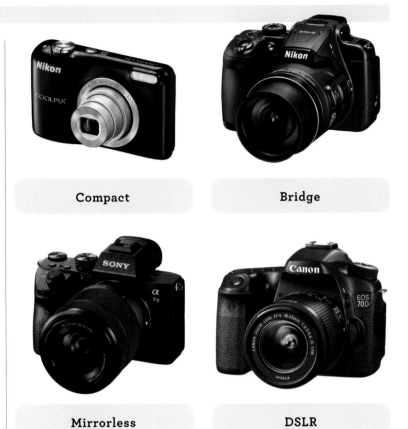

Compact

Bridge

Mirrorless

DSLR

Compact cameras

Once extremely popular, these cameras are becoming increasingly obsolete, as smartphone cameras can do the job just as well – sometimes better.

However, these cameras do still have some use, as some models are waterproof, for example.

Bridge cameras

Bridge cameras are a combination of a compact and an SLR. Smaller than an SLR and with a bit more control over image-taking than a compact, these cameras can also be cheaper than SLRs.

However, the lens cannot be changed on a bridge camera, and although there is a slight element of control, the manual settings are usually very hard to get to.

These cameras are aimed at the 'point and click' market and so I wouldn't recommend buying

one for learning photography, as you need to get to those manual settings quickly to start taking control of your photography.

Mirrorless (or compact system) cameras

Mirrorless cameras are called this because they lack the prism (or mirrors) used in other cameras. Instead of a traditional viewfinder, they have a digital screen.

These can be very good, as they generally give you access to the manual settings more easily, and they are much better quality than bridge or compact cameras.

You also have the option of using different lenses.

The really good ones are very expensive and aimed at professionals, whereas the cheaper ones are aimed at 'point and click' photographers.

Above: **Some mirrorless cameras feature an integrated viewfinder, while others require a separate accessory.**

Digital single-lens reflex cameras (DSLR)

DSLR cameras are arguably the best type of camera for learning photography. The lenses are interchangeable, the manual settings are easy to get to, they generally produce high-quality images, and they have a better built-in flash.

What's more, they are good value and upgradable. As you learn photography, you might want to get better lenses and a camera body. DSLRs give you that flexibility by offering more advanced equipment for a range of budgets.

If you really want to learn photography and have a limited budget, the DSLR camera is perfect.

Essential equipment

Tripod

Your first piece of essential equipment is a tripod. The tripod must be sturdy and stable. You need a tripod that will fully support the weight of your camera. Avoid the cheap, thin, flimsy ones.

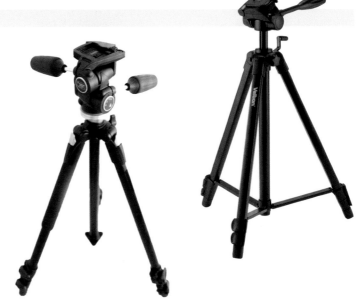

Spare memory card

Carry a spare memory card with you, as they can become full on a long shoot.

Spare battery

Also have a spare battery for your camera if you can.

Lens hood

A lens hood will help reduce lens flare and give more contrast to your shots.

Lens cleaning kit

In addition, a lens cleaning kit is also a good piece of equipment to have. Most people don't notice the huge effect that a dirty lens can have on the quality of their photos. Carry a cleaning kit and keep your lens clean at all times.

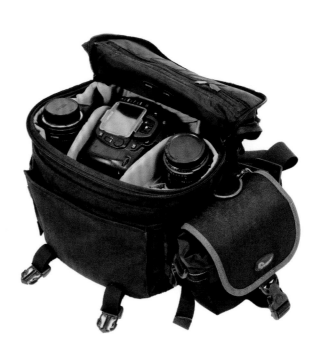

Camera bag

Lastly, a camera bag is another essential piece of kit, as it protects all of your equipment.

I personally prefer the rucksack type of bag, as it is very handy for keeping on your back all day with minimal effort.

3

Introduction to camera settings

Understanding modes

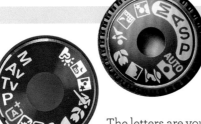

You can use most DSLRs and mirrorless cameras in Auto or Manual modes.

There will be a dial on the top of the camera with letters and pictures on: M, Av, Tv, S, A, a picture of a mountain, etc. These symbols are your camera modes.

Auto modes such as Portrait (the head symbol) will automatically give you the largest aperture possible. Landscape mode (the mountain symbol) will give you the smallest aperture possible.

To be creative, you need to take control of elements such as the aperture. Therefore, from now on, automatic modes are **BANNED!**

The letters are your manual modes.

Below is a brief description of the manual modes on your camera. Don't worry about not knowing what the photographic terms mean for now, as we will go through these in much more detail as the book progresses.

P: Program. The most automatic of the manual modes. Gives you an exposure that can be changed quickly to give different visual effects.

Tv or S: Shutter priority. You set the shutter speed and the camera will set the rest to give the correct exposure. A kind of semi-automatic mode.

Av or A: Aperture priority. You set the aperture and the camera will set the rest to give the correct exposure. Another semi-automatic mode.

M: Manual. You are in full control of the camera.

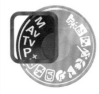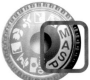

Above: **The letters are your manual modes.**

Program mode
This is the most 'auto' manual mode. It sets the largest aperture to start with, just like Portrait mode. However, you can change the exposure very quickly for different visual effects, i.e., to get the background blurred or sharp.

In Program, you get an exposure by pressing the shutter button halfway down (below). This will bring up lots of numbers on your screen or along the bottom as you look through the viewfinder.

To change the exposure settings, twist the dial (below).

Above: **This dial will be on the back of some cameras.**

I don't expect you to know what any of the numbers on the back of the camera mean yet, just that they change and that will in turn change the visual effect of the image. As the book progresses, we will learn in much more detail what these numbers mean.

It's important to know that learning is layered. Like building bricks in a wall, you need to start from the bottom and work up – you can't just put the top bricks in, as there's nothing underneath to support them.

For instance, in photography, there's no point jumping into learning about apertures and depth of field when you know nothing about the focal lengths of lenses. It'll be like jumping into a racing car when you don't know how to drive. So, in this book, we are going to learn one stage at a time so that the past knowledge will support the future knowledge, like bricks building up a wall.

Task #1

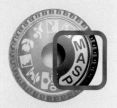

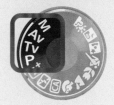

I'm going to set your first task now – think of it as a warm-up.

Take shots with your camera on all the manual settings and turn your dial to change the exposure (those numbers) between shots. E.g. set your camera to the Tv or S mode, take a shot, turn the dial several times, take another shot.

Do the same in the other modes. Make a note of what goes wrong.

Here is a brief reminder of each of the four manual modes:

P: Program. The most automatic of the manual modes. Gives you an exposure that can be changed quickly to give different visual effects.

Tv or S: Shutter priority. You set the shutter speed and the camera will set the rest to give the correct exposure. A kind of semi-automatic mode.

Av or A: Aperture priority. You set the aperture and the camera will set the rest to give the correct exposure. Another semi-automatic mode.

M: Manual. You are in full control of the camera.

Left: **Change the exposure setting using the dial, which may be on the back of your camera.**

I hope you've had a good play around there. I just wanted you to get moving around your camera and note down what went wrong. Only three things can go wrong with your exposure: your pictures can be too dark, too light or they might blur. Basically, it breaks down like this:

Correct exposure

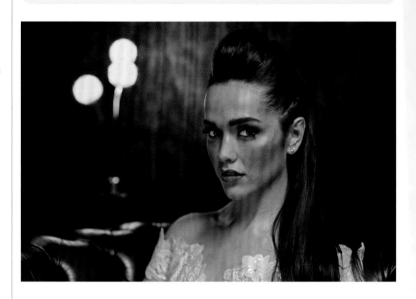

Underexposed

If your picture is **too dark**, not enough light has entered the camera; the image has been underexposed to light.

Overexposed

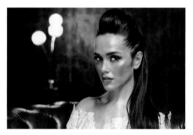

If your picture is **too light**, too much light has entered the camera; the image has been overexposed to light.

Camera shake

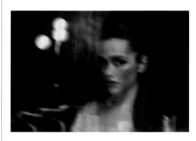

If you have a **blurred picture**, light has entered the camera slowly while the camera or subject was moving, commonly referred to as camera shake.

That's pretty much it. Your job as a learning photographer is to know how to correct these wrongs or, even better, not do them in the first place!

4

Focusing
best practices
& settings

Focusing basics

One of the first things to take control of in photography is your focus point. It can be taken for granted that you just hold the camera up and it focuses, but cameras will tend to focus on the most contrasting thing in the frame due to their automatic settings and you might not want that to be the focus point. You need to take control and focus on what you want.

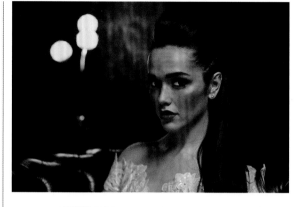

Left & below:
Controlling your focus point is very important to get right from the start.

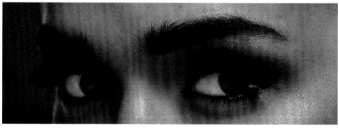

The focus point is where a viewer's eye will go first and is normally the most important part of the image. Take, for example, this photo of a model.

Your eye is immediately drawn to the eye of the model. One of the reasons for this is that the eye is the focus point of the picture.

If we crop in, we can see that the right eye of the model is sharp, and the left eye is soft.

This precise control of your focus point is what you're aiming for.

Things to note before we start:
1. Autofocus, on all cameras, needs some detail to focus on. For instance, it will not focus on a plain white wall, but will focus on a picture hung on that wall. The camera needs to see some contrast to focus on.

2. Your shutter release button has two settings. You press halfway down to focus and fully down to take the shot (below).

3. Lenses have limits on how close you can get to an object. If you're too close, your camera won't be able to focus.

i: **Normal**

ii: **Press halfway down to focus**

iii: **Press fully to take the picture**

Focus settings

There are various focus settings on various cameras, but here are the most common:

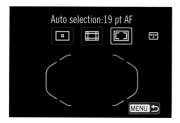

Automatic selection
The camera will focus on the most prominent part of the image. Generally, this will be what is big and near to the camera.

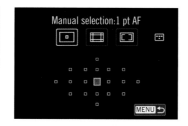

Spot autofocus
This is where you can tell the camera to focus on a particular area, for instance the centre of the frame.

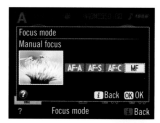

Manual focus
You control this manually from the lens. Good for low contrast or low-light situations. You can switch to manual focus on most lenses by flicking a switch on the side of the lens from AF to M or MF.

Spot autofocus
To start, we are going to use the Spot autofocus setting and set the focus point to centre frame.

Below is a guide on how to do this on most popular cameras – other camera models and brands may vary slightly. Simply look up 'spot autofocus' in your camera's manual if this is the case.

Canon
- Press the button with this symbol: ▦
- This should bring you to the focus mode screen, which looks something like this (below). Use the navigating arrows on the back of your camera to get the dot in the centre of the frame.

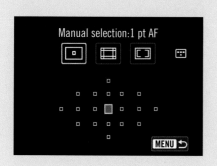

Nikon
- Press the *i* button on the back of the camera to open the setting strip at the bottom or side of most screens.

- Then use the navigating arrows to select AF-area mode. Select Single-point AF mode (right).

Focusing modes

Next are your focusing modes.

The first is Single-shot, which is called One-shot focusing on Canon and AF-S on Nikon and others. This mode is generally used for shooting things that aren't moving, for example when shooting portraits or landscapes.

The second is Continuous, which is called AI Servo on Canon and AF-C on Nikon and others. This mode is usually used for moving objects such as a fast-moving bike or car. The camera will change the focus automatically to track the moving object.

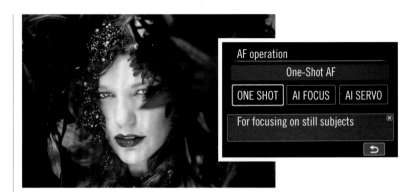

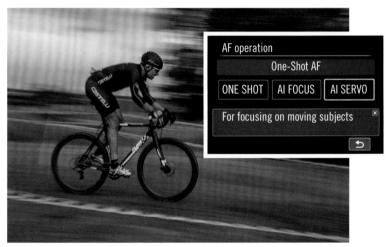

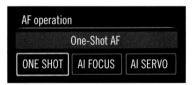

On some cameras, you also have an 'Auto detect setting', called AI Focus on Canon and AF-A on Nikon. In this mode, the camera decides if something is moving in the shot. You generally want to leave this off, as you want to take full control of the focusing on your camera.

For now, we're just going to use Single-shot, as that's the mode you'll be using most of the time, and it's best for learning photography.

On the following page is a guide on how to do this on most popular cameras – other camera models and brands will vary. Simply look up 'focusing modes' in your camera's manual if this is the case.

Nikon

▧ Press the ⓘ button, navigate to the Focus mode and select Single-servo AF (AF-S).

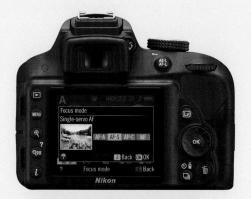

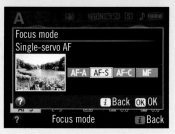

Canon

▧ Press the AF button to activate the AF operation screen. Select One Shot.

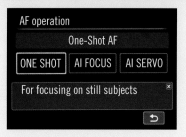

Task #2

We're going to do a little task that will help you take control of your focus point.

First, here's how to hold your camera correctly:
1. Put your right hand around the grip.
2. Put your left hand underneath the camera, resting the lens on your hand.

This is a stable position that allows you to go from shooting landscape (horizontal) to portrait (upright) orientation very quickly. It will also help reduce what's called camera shake and generally make you feel more comfortable with your camera. Give it a go now and just practise holding the camera correctly while snapping a couple of shots.

Task #3

Take control of your focus point.

1. Set your camera to P (Program setting).

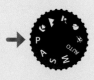

2. Set your camera to Spot AF or Single-point AF.

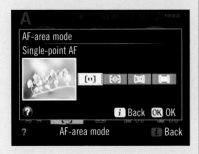

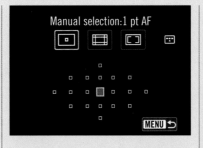

3. Set the AF (autofocus) point to the centre of the frame.

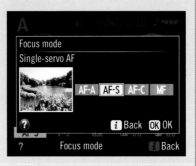

4. Set your camera to One-shot AF or AF-S (Single-shot mode).

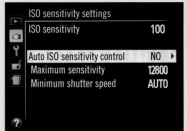

5. Set your ISO to Auto (look up how to do this in your camera's manual) and make sure you have lots of light in the room. We will learn about ISO in much more detail later in the book.

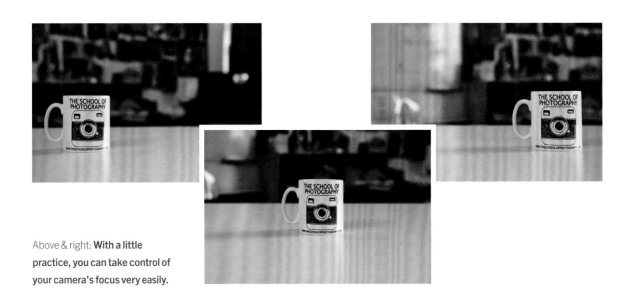

Above & right: **With a little practice, you can take control of your camera's focus very easily.**

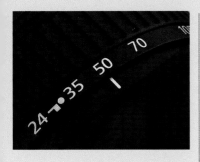

6. Zoom your lens in to about 35–50mm. Again, we will learn a lot more about lenses later in the book. Remember, learning is layered, and we will be learning one step at a time.

7. Choose an object to photograph and make sure you have a distance of at least 5m (16ft) between your object and the background.

8. Make sure your object is around 1m (3ft) away from your camera.

9. Focus on your object by pressing the shutter halfway – take the shot by pressing all the way down. (Shot A)

10. Now focus on the subject again but this time keep your finger pressed halfway on the shutter release button and move your camera to place the object in the left side of the frame. Do not release your finger in the process.

11. Take the shot by pressing all the way down. (Shot B)

12. Repeat the process so the focus point is now on the right of your frame. (Shot C)

13. You are aiming to get images similar to those below.

14. Remember the process:
Focus – Reframe – Shoot

You've just taken your first steps to controlling your photography and the focus point will now go exactly where you want it to go. Let's recap:

- Autofocusing needs some detail to focus on – it won't focus on a plain wall or in the dark because it can't see anything.

- Your shutter release has two settings: halfway to focus and fully down to take the shot.

- If you're too close to something, the camera won't focus so move back a bit and zoom in if you have to.

- While you're practising, it's best to have the camera set to One-shot focusing or AF-S, and Spot AF, placing your focus point to the middle of your frame. Then you can quickly focus on the point that you want and move that focus point to anywhere in the frame.

- And that's focusing done! Practise it some more if you need to, and then move on to the next chapter.

5

The art of composition

Composition basics

In this chapter we are going to talk about composition.

Composition, in my opinion, is one of the most important parts of photography. If I had to put one thing on top of everything else to get right, it would be composition. This is because you can make your shots look ten times better without any technical knowledge, just with the knowledge of how composition works.

In the dictionary, the word composition means combining or putting together different parts to form a whole.

Composition can apply to many subjects including music and writing. When you compose a song, you could start with the drums and bring in the guitar after 10 seconds and the vocals after another 10 seconds and in doing that, you are composing that song in that way (A).

But if you move the vocals to the start and put the drums at the end (B), you are changing the composition of that song. Composition applies to any creation that is put together using different parts.

Composition A

Composition B

In photography, composition refers to how you arrange the elements of your scene within your frame. This could mean what's in the foreground, the background, your subject, props, etc. In short, everything within your frame is an element of that picture and if you change one of those elements – let's say you move your subject from the left of the frame to the right of the frame – you have just changed the composition of that picture. Let's look at some examples.

Here is a nice, normal portrait – the subject is centre of the frame, looking at the camera and smiling. But now let's change the composition of the shot – the positioning of the model within the frame. All I've done in this instance is move closer to the model, position her to the left of the frame and asked her not to smile as much. It's completely changed the mood of the image.

You have the same person in the same place, but you have two different compositions, each giving two separate feelings.

It's really important to know that it's you, the photographer, that controls the composition of your shots. Let's take this one step further.

Here is the first image again – a nice, normal portrait with the model in the centre of the frame.

Here's the close-up image again – more focused on the face, with the model looking straight into the lens, giving a more intimate feeling.

In this image, I have moved back to make the model small within the scene. I wanted to create a sad, desolate feeling so I changed the composition of the shot to try and get that feeling.

Again, it's me that has moved, not the model. I have controlled the composition of this shot to give a different mood.

I can tell you that the model is a very happy person. She's certainly not sad as this image suggests, and that's because photography lies, and it's you that makes it lie.

You can do this just through clever use of composition. You can make someone look happy when they are sad and vice versa. You are in complete control of the composition.

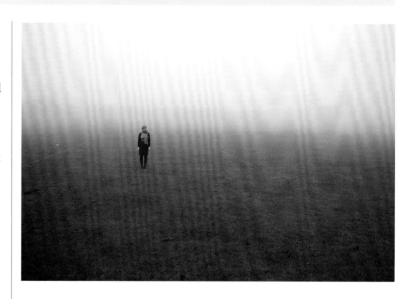

Again, we have the same person in the same place, but three different compositions giving three different moods.

Now, turn the page to look at one more image where the viewpoint has totally changed...

With the other three shots, they were pretty much taken at a normal eye height – that's me standing normally, holding the camera to my face and taking the picture. The viewpoint of your picture is where you place the camera to take the shot.

A shot taken from up high will have a high viewpoint, a shot taken from the ground will have a low viewpoint.

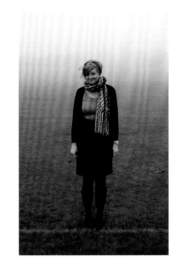

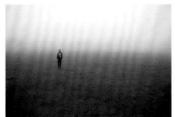

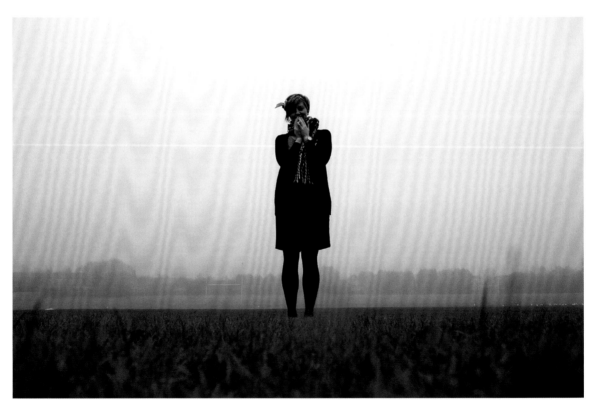

Here you can see I've used a low viewpoint, with the camera resting on the ground looking up. This has totally changed the composition of the image. Most people just continue to take pictures at eye level, but moving your viewpoint is a really easy way to change your composition and give more interest to the image.

Task #4

I want you to start to analyze and think about the effect composition has on imagery. First, write down as many words as you can to describe each of the images (right), such as happy, sad, desolate, and so on. Then write down what it is that's giving each image its own characteristics or feelings.

Let's go back to the beginning where I said that composition is how you arrange the elements in your scene. How has the changing of the elements within each of these pictures – the foreground, position of model, etc. – changed the feeling of the image?

For instance, you could say, 'The close-up picture gives a much more intimate look, as you can see clearly into the model's eyes'.

And lastly, just say which ones are your best and worst, and why that is.

I want you to analyze how different compositions affect the mood of the shot.

Analyze the composition of these shots

1. Write down as many words as you can to describe each image.
2. What elements have given each image its different look or feeling?
3. Which one is your favourite and why?
4. Which one is your worst and why?

ANSWER

There are no wrong or right answers to these questions – it's your opinion that counts. It's just as important to analyze photography as it is to make it. This, after all, how you come up with your own style.

Remember this: anything that is in your shot is part of your composition, and it is there because you wanted it to be there. So, if you have a lamp post coming out of someone's head or a wheelie bin in the background with a stray cat coming out of it, it's there because you want it to be there.

You control the composition of your shots. It's one of the easiest things to master and will start giving you great results.

Rules of composition

When it comes to composition, there are certain rules you can follow that will make your pictures seem more pleasing to the eye, or enhance a certain feeling you're going for.

These rules of composition are not just rules that photographers have invented – they are actually a result of human nature. The way humans view and interpret the world is evolutionary, and you can use these rules to your advantage to create stronger images.

I'm going to explain these rules and then set you some tasks so you can put them into practice yourself.

Rule of thirds

The first rule to talk about, and probably the most popular, is the rule of thirds. The rule of thirds means to place the main part of your image within one third of the frame.

Another easy way to do this is to place the main part of the image – in this case, the face – just off-centre.

When you position the main part of your image within one third of the frame, it tends to sit more naturally within your brain. This is because the natural world tends to be quite random – nothing is placed in an order.

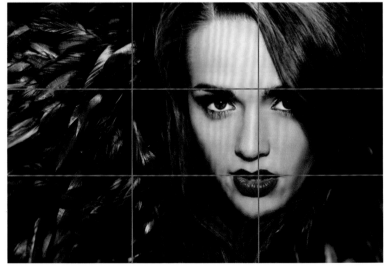

Think of trees in a forest – you don't see them growing dead straight or in perfectly formed lines without human intervention; nature will grow and form its own random patterns. Your brain subconsciously knows this, so when something is dead centre in a picture, it doesn't sit naturally in people's minds.

Putting things just off-centre, in one third of the frame, makes the shot look more natural and tends to sit easier in the viewer's eye. Here are some examples:

Compare these pictures
The first question is: which one has a more natural feel?

The second question is: which one follows the rule of thirds?

Write down your answers in your notebook.

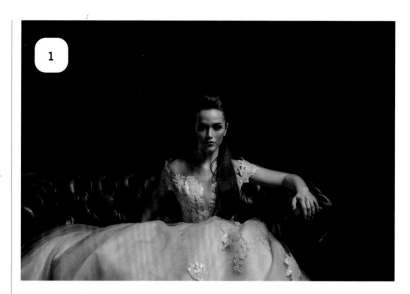

 Answer

Occasionally, you might get people say number 1, and I'll come to why that is a bit later, but most people will say number 2.

This is because number 2 follows the rule of thirds and sits more naturally in the frame and more naturally in the viewer's eye.

The rule of thirds can also apply to the horizon line.

You'll find that landscape photography often uses the rule of thirds by placing the horizon line on one of the horizontal thirds. This is to include more of the land or more of the sky in the shot – whichever has more interest.

Let's look at a few more rules of photography before I set you your task and get you working.

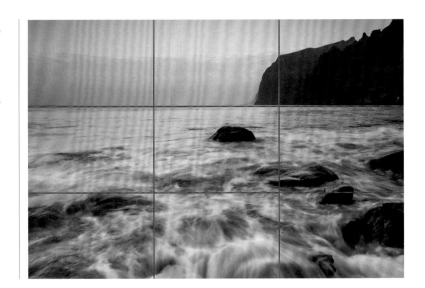

Rule of odds and evens

If you use an even number of things in your shot, you can really enhance a feeling of tension. This again goes back to nature being random. A carefully arranged even number of objects will sit uneasily in the viewer's eye, as they won't know where to look first.

This is a really good way to get people to stare for longer at an image. People tend to do this because it's not something they're used to seeing – for instance, a perfectly arranged even number of people staring into the lens.

However, if you use an odd number of things, you can enhance a natural feeling that will make you smile, or feel at ease. You can also use an odd number of things to draw the viewer's eyes to the middle object. Just think about who you looked at first in this image.

Nine times out of ten, the viewer will look directly at the middle person first. And you can control that by a simple use of composition.

Remember that composition is there to enhance the look of your shot, not make it. So, if you've got two people in your shot and they're laughing and having a good time, that feeling of tension won't be there.

Use composition to enhance the feeling of your shot.

Let's look at some more rules...

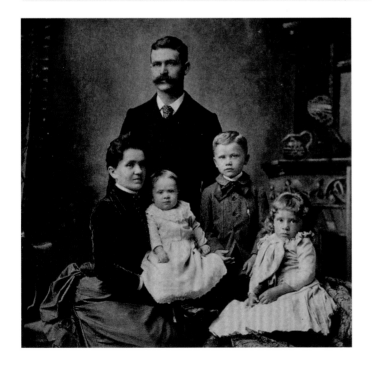

Rule of triangles
Look at this old Victorian family picture.

Can you spot any triangles in this image?

Take your time and write some ideas down in your notebook if you want.

 Answer overleaf

Answer

Hopefully, you have seen that all the people together form a big triangle, which was common for a Victorian family photograph – the man's head being the top of that triangle.

So, the next question is this:

Why were triangular compositions often used in these Victorian family portraits?

Take some time to write down some answers in your notebook if you want.

Answer

Triangles tend to form stable, solid-looking compositions. Triangles are the strongest shapes in nature and in construction because any added force is evenly spread through all three sides. Think of roofs of houses or the Egyptian pyramids. Subconsciously, our brains know this and that is why if you use a triangular composition, you enhance a feeling of strength or hierarchy. In this case, it's been used to show the hierarchy throughout the family: the man sitting proudly at the top with his family below him; he is in charge of that family.

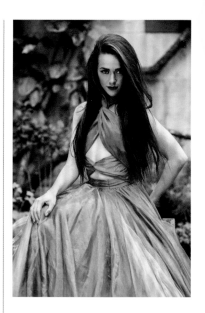

If you want someone to look powerful, get them to sit up straight, look down onto the camera and hold their arms and shoulders wide. Create a triangular composition to enhance a feeling of strength.

Rule of space

Now let's look at the rule of space. Take a look at these two images (right).

Which one looks better and why? Write down some notes.

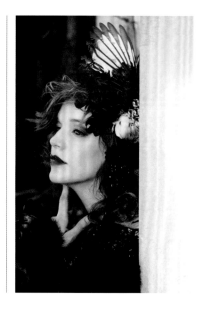

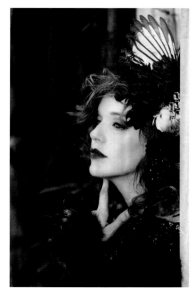

On the right, the model sits much more naturally within the scene. This is because she is looking into the space.

Having space in an image can be a good thing as long as it's placed correctly.

On the left, the model looks like she has been squeezed into the frame. She looks cramped and squashed in.

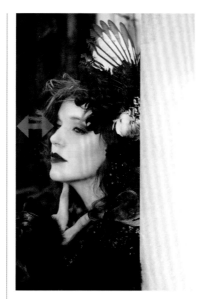 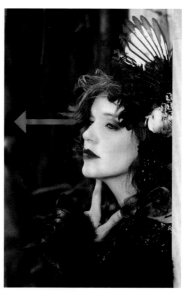

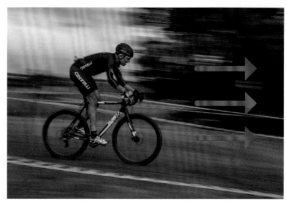

The same rule also applies to moving objects. Always have the space in the direction the object – in this case, a mountain bike – is moving.

Frame within a frame

Now let's look at a technique called 'frame within a frame'. Frame within a frame means exactly that – you find something to frame your main subject and include that in your picture, therefore creating a frame within a frame.

This image of someone looking through the hole of a bin is a simple example.

Another simple example is having someone looking through an opening, or positioned in front of a window, and including the frame in the shot. It's a great way to lead your viewers' eye into the main part of the image.

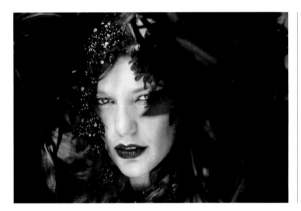

But you can be a bit more creative with this technique.

In this image, the model was wearing a dress which had feathers along the arms, so I asked her to hold her arms above her head to create a frame of feathers I could shoot through.

A good tip is to shoot through the model's arms, or through a furry coat or even a scarf.

Rules of composition

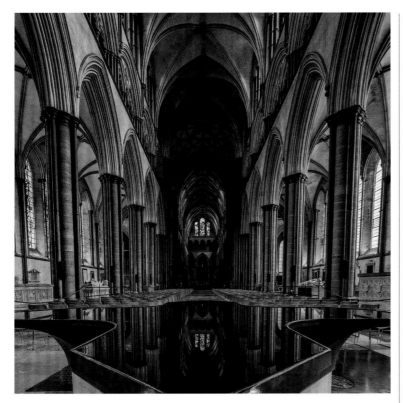

Symmetry

The next composition technique to look at is symmetry.

Using symmetry blows the whole idea of the rule of thirds out of the window. How can symmetry look good if the rule of thirds looks good?

Remember that these composition techniques are there to enhance the feeling of the shot. So, where the rule of thirds will give you a more natural composition, symmetry will give you an unnatural composition. It can create a clean, clinical and ordered look.

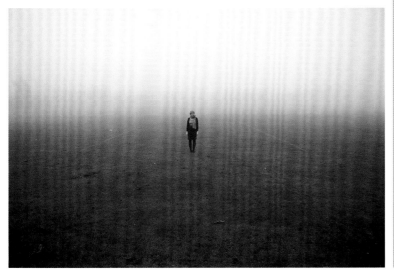

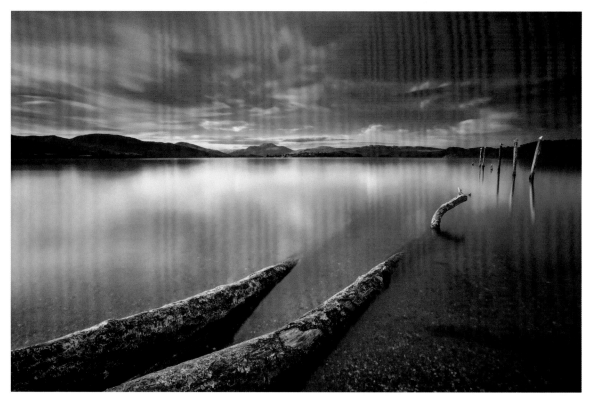

Leading lines

The 'leading lines' technique is where you use objects within your scene to lead the viewer's eye from the foreground to the background. In this picture, I've used a fallen tree in the foreground to lead you into the wooden posts, which then lead you into the distance.

In this shot (right), I used this path to lead your eye into the scene. Leading lines are a great way to add interest to the foreground of landscape shots.

There are a lot more rules of composition, but the ones I have discussed here are the most common.

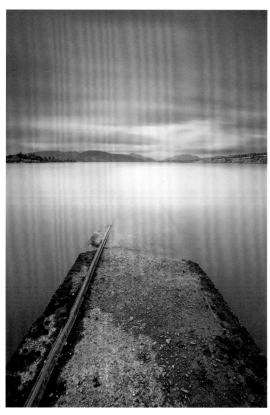

Task #5

Take shots which show the use of good composition.

1. Set your camera to the P setting and put your ISO on Auto. Choose all or a few of the following rules to practise with. You can use people, buildings, landscapes, etc. What matters is how you are using composition to enhance the look of your shot:

Rule of thirds – rule of odds and evens – rule of triangles – using space – frame within a frame – leading lines – symmetry.

Remember that everything in your frame is there because you want it to be.

2. Note down which composition has worked best and why.

3. Note down which one hasn't worked and why.

Remember, making mistakes is important for learning. Make notes so you don't make those mistakes again.

We always like to see students' work here at The School of Photography. So, if you want to show us, tag your pictures on social media with #theschoolofphotography so we can see them.

To view video tutorials on using composition in photography, go to **www.theschoolofphotography.com** and type 'composition' in the search bar.

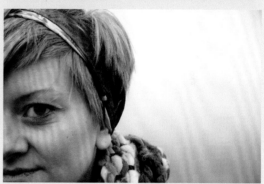
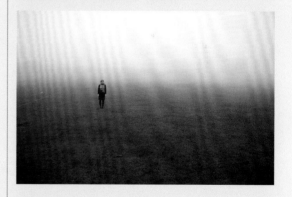

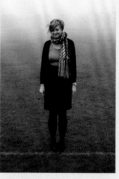

Composition recap

Let's recap what we've looked at:

Rule of thirds
Place your main subject within one third of the frame. When you do this, the main subject tends to sit more naturally within the viewer's eye.

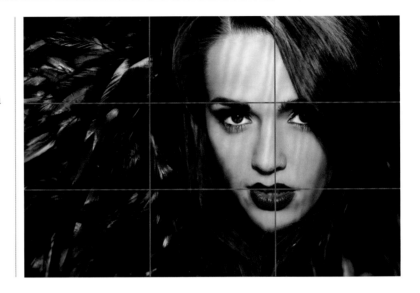

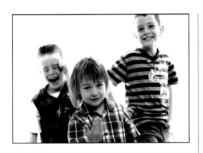

Rule of odds
An odd number of subjects in an image often has a more natural feel. You can also use an odd number to draw the viewer's eye to the middle object.

Rule of evens
An even number of objects can enhance a feeling of tension or an unnatural look.

Rule of triangles
Triangular compositions can be used to enhance a feeling of strength.

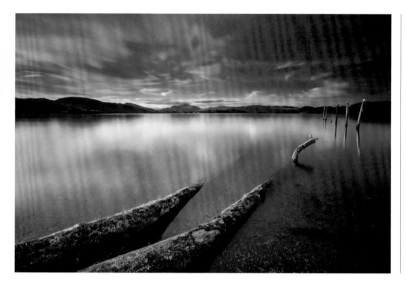

Leading lines

Use objects within your scene to lead the viewer's eye from the foreground to the background.

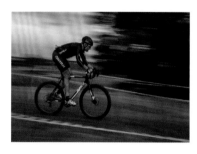

Using space

Place empty space in the direction the person is looking or the object is going. This will allow for the person or moving object to move into the space.

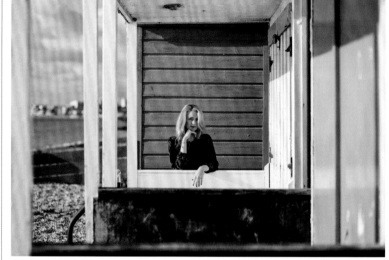

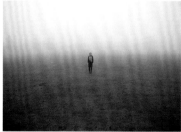

Symmetry

Using symmetry will give you an unnatural look. It can create a clinical, ordered feeling.

Frame within a frame

Find something to frame your main subject and include it in your picture, therefore creating a frame within a frame. This gives more interest to the picture and focuses the viewer's eye on the main part of your image.

That's the end of this chapter on composition. Now go outside, give it a go and move on to the next chapter when you are ready.

6

Lenses & focal lengths

Lenses

This chapter is about camera lenses and their focal range. First, let's look at the types of lenses you can get. One is a fixed focal length lens, often referred to as a prime lens, and the other is a zoom lens.

A **prime lens** has a fixed focal length. That means you can't zoom in or zoom out. Instead, you have to physically move forwards and backwards to enable you to get more or less in your shot.

The pros to these types of lenses are that they have much better optics and you can get wider apertures built into them for less cost. We are going to look at apertures and the benefit of wider apertures in chapter 9.

The con to this lens type is that it has a fixed focal length.

+ **Better optics**
+ **Wider apertures**
+ **Less cost**

− **Fixed focal length**

However, I find that having a fixed focal length is not such a bad thing. It makes you think about framing and composition more, as you physically have to move around. Personally, I think there's not much wrong with a prime lens and I recommend you get one if you can.

Then you have a **zoom lens**, which zooms forwards and backwards to get more or less in a shot.

The pros to these types of lenses are that one lens fits all and you can zoom in and out quickly.

The cons are that they generally have a reduced image quality and smaller apertures. If you want better quality and wider apertures in a zoom lens, they will generally cost a lot of money.

+ **Zoom in and out very quickly**

− **Generally lower quality**
− **Smaller apertures**
− **Good ones are usually expensive**

Focal lengths

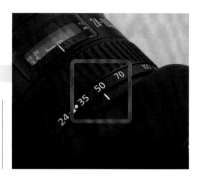

Before we look at what focal lengths are, I want to explain to you where to find them on your camera.

If you look at the top of your lens (top right), you will see a little red or white dot or line, depending on your camera. As you twist your lens in or out, you'll see that it corresponds with a number. That is your focal length. So, when the white line matches up with the number 50, your current focal length is 50mm. Whatever that dot/line corresponds with, that is the focal length you will be shooting at.

In a nutshell, the smaller the number, the wider the angle of view and the more you're going to get into your shot. The higher the number, the more zoomed in you are and the less you're going to get into your shot.

Here I am zooming through the focal lengths, from 16mm to 300mm, to show the effect this has on an image.

16mm

28mm

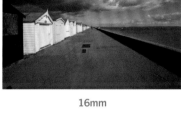
35mm

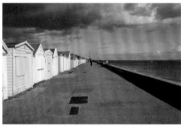
50mm

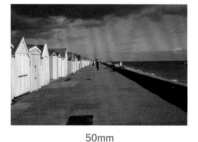
80mm

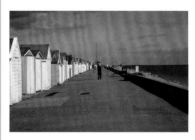
100mm

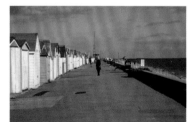
200mm

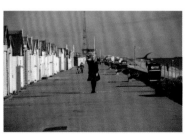
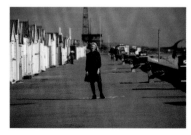
300mm

A lot of people think that a zoom lens is just to get closer, or to zoom out if you're too close to something. In general, the learning photographer will use their zoom lens because they can't be bothered to physically move forwards or backwards. That's not a good thing to do!

You need to use the focal range of the lens to get the desired effect that you want, not because you can't be bothered to move forwards or backwards. That's really important and here's why...

16mm

100mm

Here's a picture of someone taken at an ultra-wide angle. This picture was taken at a focal length of 16mm using a full-frame camera. I'll come to full-frame cameras in more detail soon (see page 54).

The picture here is of the same person, but this picture was taken at a focal length of 100mm. Look at the difference in the two pictures. That is solely down to the focal length used – you could be forgiven for thinking that it's not even the same person.

16mm

28mm

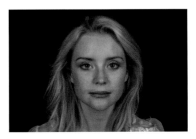

50mm

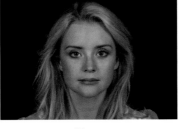

80mm

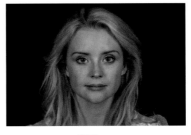

100mm

Let's look at the same picture through a variety of focal lengths.

The 50mm picture is really important because it's actually how your eye sees. Using a 50mm focal length on a full-frame camera will give little distortion. This means you can take a picture and put it next to the person and it should look exactly the same. This is known as a 'standard' lens.

A focal length of around 80mm is very good for portraiture, as it compresses the face a little bit, giving a more flattering portrait.

Notice through these pictures how the head is framed the same. For instance, the nose is in the centre of each image and the head size is taking up roughly the same amount of space in each frame. This is because you're going to be doing this yourself in the next task.

Focal lengths

Task #6

For this task, it's best to use something cubical or a face close-up to see the distortion fully. I have demonstrated this using a bus shelter.

I want you to physically see, with your own equipment, the effect that the lens's focal length has on objects.

16mm

28mm

35mm

50mm

80mm

100mm

1. Take pictures of the same object with different focal lengths and notice how they can distort an object. Don't worry if you don't have the same numbers shown above – simply start at your lowest number and work up in stages.

2. Set your camera to P (Program mode), put your ISO on Auto and have your focus point set to the centre of the frame.

3. Fill the frame with the object equally in each shot, have your focus point the same and make sure your wide-angle shot is as close to the object as possible.

Sensor sizes

I want to talk to you about sensor sizes, as this also has an effect on the focal length that you use. A 50mm focal length will look different on what's called a full-frame camera, a crop sensor camera and a Micro Four Thirds camera. Your sensor is what captures the light and is held in the camera body.

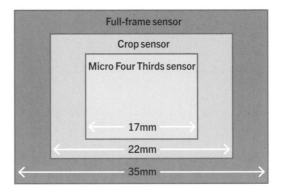

Full-frame sensor

Crop sensor

Micro Four Thirds sensor

17mm

22mm

35mm

The main difference between a full-frame and a crop sensor is size. The full-frame sensor is based on the old 35mm negatives, which means it's 35mm along its longest side, whereas a crop sensor is around 22mm on its longest side and a Micro Four Thirds sensor is 17mm along its longest side.

The main reason manufacturers do this is money. A full-frame camera will cost you a lot more – and is generally what professionals use.

The quality of the image is going to be better on a full-frame camera, but the difference will be minimal and only visible on big screens and prints, so don't worry too much about this as you're learning. What it does affect, however, is the amount you can fit into your frame. Let's look at the effect of this in an actual picture.

Here we have a picture that's been taken on a full-frame camera (below). The focal length used was 50mm.

If I took the same shot with a crop sensor camera, and set the lens to 50mm, I would have got this (below), which is a cropped version of the full-frame image.

To get the equivalent look on a crop sensor, I would have to zoom out. On the crop sensor camera, you would have to zoom out to 31mm to get the equivalent of 50mm on a full-frame camera.

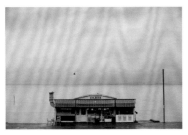

Full-frame – 50mm

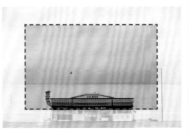

Crop sensor – 50mm

Let's look at another example. Here we have a picture of my dog Jake taken on a full-frame camera with a focal length of 80mm (below).

The same picture taken with the same focal length on a crop sensor camera would look like this (below).

So, to get the equivalent look on a crop sensor camera, you would have to zoom out to 50mm.

A 50mm focal length on a crop sensor camera is equivalent to 80mm on a full-frame camera and 40mm on a Micro Four Thirds camera (see table below).

I know this all sounds confusing, but it's not something you have to worry about too much unless you're going to change cameras. However, you do need to know what types of focal lengths suit what types of subjects.

Of course, you can use any focal length for any picture and it is good to experiment, but there are general focal lengths that will suit certain subjects.

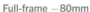

Full-frame — 80mm

Crop sensor — 80mm

Full-frame cameras with 35mm sensor	Crop sensor cameras with 22mm sensor (approx.)	Micro Four Thirds cameras with 17mm sensor	Type of lens and typical use
16mm focal length	11mm	8mm	Ultra wide-angle
28mm	17mm	14mm	Wide-angle – good for landscapes
50mm	31mm	25mm	Standard lens – as your eye sees
80mm	50mm	40mm	Good lens for portraiture
100mm	62mm	50mm	Good lens for macro (close-up photography)
200mm and above	125mm	100mm	Zoom lens – good for wildlife and sports

Below is an example of a shot taken on a full-frame camera at a focal length of 16mm. To get this look on a crop sensor camera you would have to use a focal length of 11mm, and on a Micro Four Thirds camera a focal length of 8mm. These focal lengths are called ultra wide-angle and they're really good for taking those unusual landscape shots where you capture a lot of the scene in the picture.

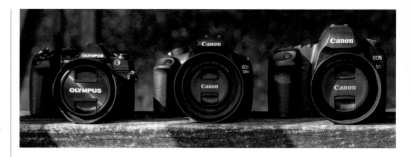

Olympus OM-D Micro Four Thirds camera

Canon EOS 1200D crop sensor camera

Canon EOS 5D full-frame camera

Full-frame cameras with 35mm sensor	Crop sensor cameras with 22mm sensor (approx.)	Micro Four Thirds cameras with 17mm sensor	Type of lens and typical use
16mm focal length	11mm	8mm	Ultra wide-angle
28mm	17mm	14mm	Wide-angle – good for landscapes

A standard DSLR camera with a standard kit lens will probably have a widest angle of approximately 17mm.

The equivalent of that will be 28mm on a full-frame camera and 14mm on a Micro Four Thirds camera.

These lengths are good for general wide-angle shots and landscapes.

Full-frame cameras with 35mm sensor	Crop sensor cameras with 22mm sensor (approx.)	Micro Four Thirds cameras with 17mm sensor	Type of lens and typical use
50mm	31mm	25mm	Standard lens – as your eye sees

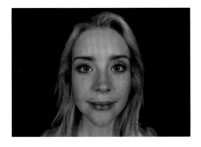

Above: **16mm – the face is distorted.**

Above: **50mm is commonly used in documentary and product photography.**

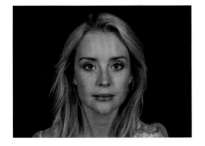

Above: **50mm – as your eye sees.**

A standard lens – as your eye sees – is 50mm on a full-frame camera, 31mm on a crop sensor camera and 25mm on a Micro Four Thirds camera. If you want something to look natural then this is a good focal length to use.

Full-frame cameras with 35mm sensor	Crop sensor cameras with 22mm sensor (approx.)	Micro Four Thirds cameras with 17mm sensor	Type of lens and typical use
80mm	50mm	40mm	Good for portraiture

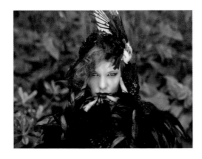

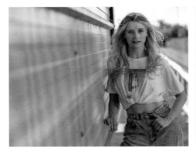

A really good focal length for portraiture is 80mm on a full-frame camera, 50mm on crop sensor camera and 40mm on a Micro Four Thirds camera. It throws the background or foreground out of focus and compresses the face a little.

Full-frame cameras with 35mm sensor	Crop sensor cameras with 22mm sensor (approx.)	Micro Four Thirds cameras with 17mm sensor	Type of lens and typical use
200mm and above	125mm	100mm	Zoom lens – good for wildlife and sports

Zooming in further, you get the lenses generally used for sports and wildlife photography where you need to photograph things that are far away.

So, have a practice with your task and make sure you're comfortable with how different focal lengths can affect the look of your shots, then move on to the next chapter.

To view a video tutorial on camera sensor sizes, go to **www.theschoolofphotography. com** and type 'sensor size comparison' into the search bar.

7

Metering

Metering modes explained

Every modern DSLR has something that's called a metering mode.

Knowing how metering works and what each of the metering modes do is very important in photography, as it helps control exposure with minimum effort. It also helps you take pictures in unusual lighting situations, for instance where you have a lot of contrast between lights and darks, such as a shot where you have a person standing in front of a bright window.

Exposure in photography is something we are going to cover in much more detail later on in this book, but to briefly give you an understanding of it, an exposure is how much light you let into the camera.

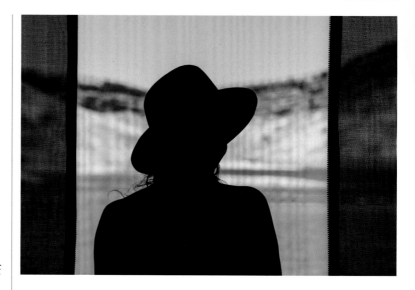

Too much light and the photo becomes too bright, or overexposed. Not enough light and the photo becomes too dark, or underexposed. Metering in your camera is what determines the correct amount of light needed for any particular shot.

First, let's show you where your metering settings are on your camera. Below is a guide for common cameras. Other cameras will be very similar to this so just refer to your user manual under 'Metering modes' if you get stuck.

Canon

■ Press the Info button to bring up this screen.
■ Using the touchscreen or the navigator wheel, select the symbol highlighted below and press Set or tap it on the touchscreen.

Nikon

■ Press the ℹ️ button and the bottom setting strip should come up.
■ Using the navigator wheel or buttons, select the symbol highlighted below.

There are several different metering modes on your camera.

 The first one is called **evaluative** or **matrix metering**, depending on what camera you have. That's the default metering mode and works really well. It measures the light from across the frame but puts a bias where the focus point is.

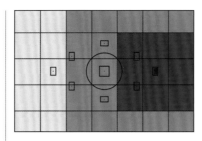

On this picture (above), the dark blue dot is where the focus point is and where most of the information is recorded from. Directly surrounding that is

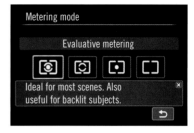

where it takes further information from and surrounding that is the rest. Evaluative metering mixes all three areas together and gives you a balanced exposure.

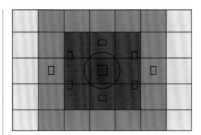

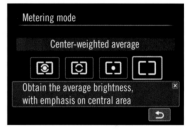

The next one is called **centre-weighted** or **average metering**. This measures light from across the whole frame but its bias is around the centre. It ignores the focus point. This can be good for landscape situations when you might be focusing on something in the foreground but you want the camera to balance the exposure for the whole shot.

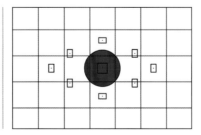

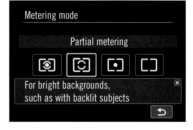

On some cameras you have **partial metering**. This mode measures light from a small part of the picture – around 10 percent of the frame around the focus point.

Then there is **spot metering**, which does exactly that. It meters from your focus point, which is 2–4 percent of the image area. Partial and spot metering are good settings for challenging lighting situations, especially when you have a moving subject.

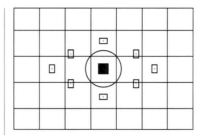

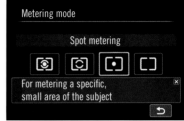

Task #7

I want you to find a challenging situation. A really easy way to do this is put an object in front of a window so you have something very dark against something very bright.

Take shots using different metering modes and note down the differences. Have a practice with this and then move on when you're ready.

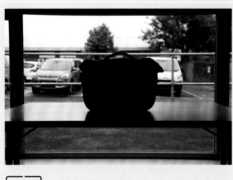

Evaluative or matrix

Partial

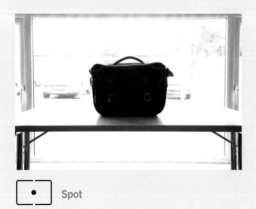

Spot

Centre-weighted

Exposure compensation

As well as metering, there is another way to control exposure. It's called exposure compensation and you simply use it to make your pictures brighter or darker.

For example, imagine you're taking a picture of a sunset and it has come out too bright. By using exposure compensation, you can tell the camera to let in less light, to underexpose the picture. This means the picture will come out darker, resulting in a much deeper, better-looking sunset.

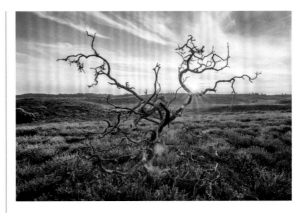

Left: **Original** exposure.

This is the exposure compensation symbol found on most cameras. Here's how to do this technique on your camera. Again, this is a guide for common cameras – other brands will be very similar. Refer to your camera's manual under 'exposure compensation' if you get stuck.

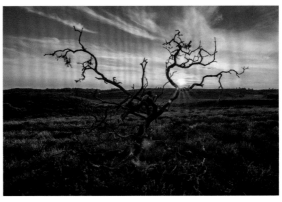

Left: **With** exposure compensation set to -1.5 stops.

Canon

■ Press the button that looks like this: ✎
■ While holding this down, move the dial on the back or top of your camera to move the dot left or right of the '0' (as highlighted below). The '0' is correct exposure, the '−' numbers are underexposed and the '+' numbers are overexposed.

Nikon

■ Find the Exposure Compensation button: ✎
■ Then, holding this button down, use the dial at the back or front of the camera to move the exposure to a '+' number or '−' number. The '−' numbers are underexposed and the '+' numbers are overexposed (highlighted below).

Task #8

Practise using exposure compensation.

Set your camera up in one position and take some pictures at different exposures, e.g. -1, -2, +1, +2, etc. If your camera goes to -/+ 3 or 4, try that as well.

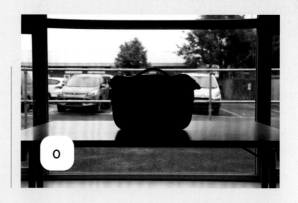

0

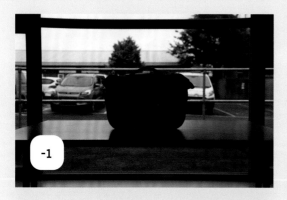

-1

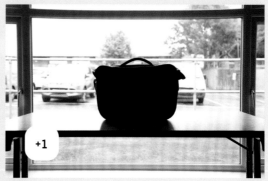

+1

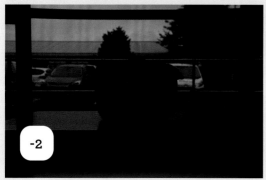

-2

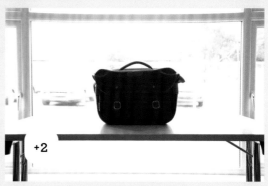

+2

1. Set your camera to P and the ISO to Auto.
2. Take one shot at the camera's normal exposure.
3. Using exposure compensation, change the exposure to –1 and take another picture.
4. Now change the exposure to -2 and take another picture.
5. Repeat the process throughout your camera's range e.g. +1, +2 etc.

Compare each shot and notice the difference in brightness. By doing this, you have just controlled the exposure of your shots.

Important! Make sure you put your camera back to '0' when you finish this task.

Metering recap

Let's recap on this chapter:

- You have different types of metering modes on your camera that can be used to your advantage.

- The two main ones are evaluative (or matrix) and spot metering.

- Spot metering will help you out in difficult situations when you just need to meter for one particular object.

Evaluative or matrix

Spot

Partial

Centre-weighted

 Then you have exposure compensation. Exposure compensation is a really quick and easy way to just brighten or darken your pictures. It's really good for sunsets,

someone standing in front of a window or to create silhouettes.

Generally, the camera's default setting, which is evaluative or matrix metering, does a really good job. You would only use

other metering modes and exposure compensation if the exposure is not coming out correct, i.e. if your picture is coming out too dark or too light.

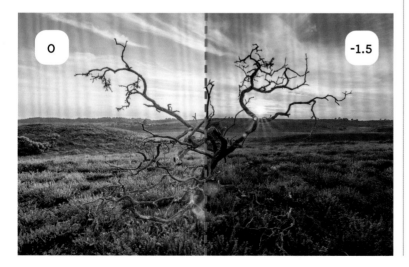

There are more advanced ways to control the exposure of your shots and we'll cover that later. For now this is a good way to understand exposure and just get a bit more control over the look of your shots.

Have a good practice with this and when ready, move on to the next chapter.

ISO

ISO stands for International Organization for Standardization. It's used to standardize certain products or certain parts of products across the world. You have ISO for products such as glass and wood and, in this case, photography.

ISO in photography refers to the sensitivity of your camera's sensor to light. Basically, you can make your camera more or less sensitive to light using the ISO settings. You will see it displayed on your camera as ISO 100, ISO 400 and so on. The lower the number, the more light you will need and the less noise the image will have. The higher the number, the less light you will need and the more noise the image will have.

ISO 25,600 (H2)
1/1,000 second @ f/8

ISO 6,400
1/250 second @ f/8

ISO 1,600
1/60 second @ f/8

ISO 400
1/15 second @ f/8

ISO 100
1/4 second @ f/8

Now let's look at what noise is. Look at this picture (above).

It's one picture taken at five different ISO settings. At the bottom you've got ISO 100 and at the top you've got ISO 25,600. If you look at both sections, you can see that the top one (ISO 25,600) is very speckled – this is noise.

Noise used to be called grain in the days of film photography, but in the digital age it's called noise and it doesn't look as good.

Here is the ISO 25,600 picture (far right). It's really noisy, the colours are broken and the image looks soft and very dull.

If we look at the same image taken at ISO 100 (right), you can't see any of that noise. It's nice and clear, the colours are vibrant and there are no dots.

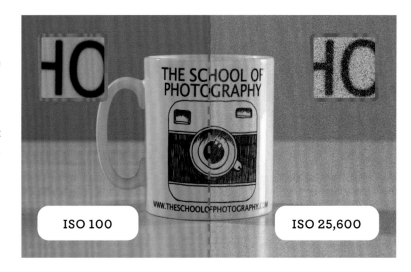

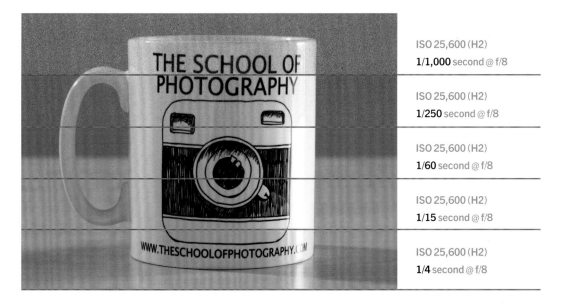

ISO 25,600 (H2)
1/1,000 second @ f/8

ISO 25,600 (H2)
1/250 second @ f/8

ISO 25,600 (H2)
1/60 second @ f/8

ISO 25,600 (H2)
1/15 second @ f/8

ISO 25,600 (H2)
1/4 second @ f/8

Look at the shutter speeds – that's the numbers where it states '1/1,000 second'. Look at the one that says ISO 100, which has been taken at 1/4 second. If you look at the one that has been taken at ISO 25,600, that has been taken at 1/1,000 second.

We will cover shutter speeds in much more detail later on in this course, but in a nutshell this means the high ISO shot has

been exposed to a lot less light while the ISO 100 shot has been exposed to a lot more light.

Because I didn't let in a lot of light for the top image, the high ISO has captured the light extremely quickly, which means it hasn't captured all of the detail, just as much as it could within that time, and filled in the gaps as best as it could. That's what's creating the noise.

As a comparison, think of when you're listening to the radio. When you're near to the radio station's antenna, you can hear it quite clearly, but as you get further away, the sound starts to crackle and break. This is because the radio doesn't have as much detail to play you so it fills in the gaps with noise.

So, when would you use different ISO settings? With post-processing these days, you can add the grain effect into your images. So, ideally, what you need to do is capture as much detail as possible in each picture you take, which means having a low ISO. If you have got a lot of light – for example, outside on a sunny day – you can use ISO 100, as you have a lot of light available and this will give you the best image quality.

You would use a high ISO when you haven't got much available light, for example inside a concert or a restaurant at night when you don't want to use the flash. Flash could distract and bleach out features in a face, so a high ISO will get the shot for you, but the trade-off for that will be noise.

ISO settings

Before I set you the ISO task, I want to show you where the ISO settings are on your camera. Again, this is a guide for common cameras, so don't worry if you don't have a Canon or Nikon – it's pretty similar on all makes of camera. Simply refer to your camera manual under 'ISO settings' if you get stuck.

Canon

▓ Press the button marked ISO (on top or at the back of the camera).
▓ Turn the dial to select what ISO sensitivity setting you want, then press Set.

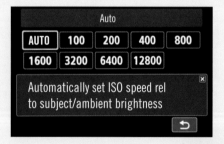

▓ For the next task, you may also want to use a 2-second timer to avoid camera shake.
▓ Press the Drive mode button on your Canon (pictured right, showing multiple squares).
▓ Then select 2-second self-timer from the options and press Set.

Nikon

▓ Press the Menu button and select the camera icon (highlighted green).

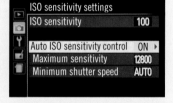

▓ Scroll across and down until you find the ISO sensitivity settings. Press OK.
▓ Make sure Auto ISO sensitivity control (highlighted yellow) is off.
▓ Press the shutter release to go back to the main screen.
▓ To change the ISO now, just press the 🛈 button.
▓ Scroll left or right until you get to the ISO setting (highlighted in yellow box).
▓ Press OK and you should now be able to change the ISO sensitivity settings.

▓ To activate your self-timer, press the Drive mode button (right) and select the 2- or 10-second timer option.

Task #9

Practise using ISO settings.

1. Rest your camera on a table or put it on a tripod to keep it still during the exposures. Do this task inside.
2. Set your camera to its P setting and change the ISO setting manually.

3. Take two pictures of the same object – one picture at your lowest ISO setting and one at your highest ISO setting.
4. Transfer them onto your computer or zoom in on the camera screen and see the difference between the two shots.

ISO 100 **ISO 25,600**

I hope you can see the difference between the two images. All I wanted you to do there was be able to change ISO manually and recognize within your own pictures when you have noise.

So, you use ISO to make your camera more or less sensitive to light. Ideally, you would want to set ISO to 100 all the time to get no noise in your images, but for that you would always need lots of light and, as we know, photography doesn't work like that. ISO comes into play mainly in low-light situations where you don't want to use the flash and you're handholding the camera.

We are going do a lot more on controlling and balancing exposures with ISO later on in the book. Remember that learning is layered – one step at a time – and if we do it one step at a time, you're going to retain that information better. So, for now, your main focus is to know what ISO is, how to change it on your camera, and to recognize that high ISO creates noise in your images.

Let's recap:
- Your ISO setting controls how sensitive your camera's sensor is to light. A low number will require more light while a higher number will require less light.

- A disadvantage of a higher ISO is noise in your image, with the advantage being you can take pictures in low-light situations without using the flash or getting camera shake.

- When you've practised with this, move on to the next chapter.

9

Apertures & depth of field

Apertures & depth of field

In this chapter we are going to talk about apertures and depth of field in photography. Before we get started on that, I want you to answer this question:

What is an exposure in photography?
Write down what you think the answer to that question is...

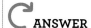

ANSWER

I ask this question because people often say it's the amount of time you expose for, or it's when the camera takes a picture, and these are partly true. An exposure in photography is the amount of light you expose your camera's sensor to. It's not just the time you expose for – it's the amount of light you let into your camera. People can get a bit confused with this term, so I want to clarify it first.

An exposure in photography is made up of two things, the first being your aperture and the other being your shutter speed. So, you can have an exposure of 1/60 second at f/8 (highlighted red), with f/8 being the aperture. Apertures are what we are going to look at in this chapter.

Using an old lens, I can manually show you how the aperture looks. The below left picture shows a small aperture and the right picture shows a large (or wide) aperture. An aperture is held within the lens and is basically a hole that you can increase or decrease in diameter to allow in more or less light, just like the pupil in your eye. When it's bright, your pupil goes really small to block the light, and when it's dark, your pupil goes really big to let in more light.

Apertures are identified by a series of numbers with the letter 'f' in front of them. You might have seen them on your camera, showing f/8 and f/5.6, and so on. The 'f' stands for focal ratio.

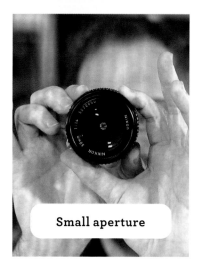

Small aperture

Large aperture

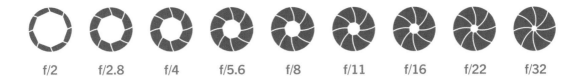

| f/2 | f/2.8 | f/4 | f/5.6 | f/8 | f/11 | f/16 | f/22 | f/32 |

Let's look at a typical aperture sequence found on an SLR camera. The illustration above shows a series of numbers below the apertures.

The lower the number, the bigger the hole, while the bigger the number, the smaller the hole. That's the first confusing thing to try and get your head around – it's back to front! The particular f/numbers above are really important. You really need to learn these numbers and we'll talk about why that is as this chapter progresses.

You'll also find numbers in between these (right). They are called 1/3 stops and I would recommend that you ignore them for now and only use the main f/numbers until you are more confident with apertures.

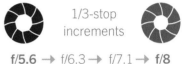

1/3-stop increments

f/5.6 → f/6.3 → f/7.1 → f/8

Task #10

For now, just as a little warm-up, I'm going to get you to use the Aperture-priority setting on your camera.

It's called Av or A and is where you tell the camera what aperture you want to shoot at. The camera will set the shutter speed and ISO for you, if you have your ISO on auto, to give you the correct exposure to light.

Take a few pictures using different apertures. I just want you to see what happens and I want you to be a bit more comfortable in the Aperture-priority setting. Below is a guide on how to do this on common cameras. If you get stuck, refer to your camera's manual under 'aperture priority'.

Canon

■ Turn your wheel to Av (Aperture priority). Now, when you turn the dial on top of the camera, your f/number will change.
■ Make sure your ISO is set to Auto. Your camera will now change the shutter speed and ISO to correctly expose for the f/number.

Nikon

■ Turn your wheel to A (Aperture priority).
■ Turn the dial on the back or front of the camera – you should see the f/number changing.
■ Make sure your ISO is on Auto. Your camera will now change the shutter speed and ISO to correctly expose for the f/number.

Now for some maths!

When you're balancing light coming into your camera, you need to know some mathematics I'm afraid – it's just part of photography. I'm going to give you a quick question. Here's a picture showing f/4, f/5.6 and f/8. When you go from f/4 to f/5.6, you are reducing the amount of light. You can see that quite clearly, as the hole is getting smaller.

f/4

f/5.6

f/8

How much, in a percentage, is the light being reduced by?
You're just having a guess for now, but it's more simple that you think!

↻ **ANSWER**

If you're going from f/4 to f/5.6, you are reducing the amount of light by half. If you go from f/5.6 to f/8, you are halving the amount of light again. If you go the other way, from f/8 to f/5.6, you're doubling the amount of light. This is one of the reasons why these numbers are so important and why the 1/3 stops are not so important at this stage of your learning.

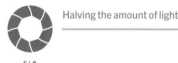

f/4 → Halving the amount of light → f/5.6 → Halving the amount of light → f/8

Also, if you go from f/4 to f/5.6, you are going 1 stop down. If you go from f/5.6 to f/8, you are going another stop down. This is when it starts to get complicated, but try to simplify it in your head by associating it with light not numbers for now. Is the amount of light you let into the camera more or less than before? If it's more light, you're 'stopping up'. If it's less light, you are 'stopping down'.

f/4 → Halving the amount of light / Down 1 stop → f/5.6 → Halving the amount of light / Down 1 stop → f/8

This is important to know, as it's a professional term and knowing your stops will make balancing exposures very easy. For instance, if an image is too dark, it's common to say that it needs to be a stop brighter, which basically means double the amount of light coming into the camera. You also use stops in shutter speeds, ISO and post-processing software, so getting used to them is really important to gain full control of your exposures. It will take time and practice, but will be worth it in the end.

Here's another picture just to reinforce this. If we start at f/4 and go to f/11, we are going 3 stops down. What that actually means is you're reducing the light by half, half and half again.

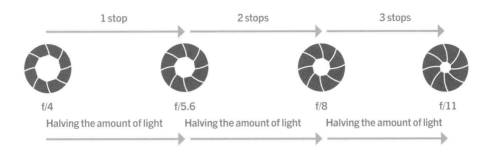

Let's go back to the aperture sequence. The wider the aperture, the more light you're letting in. The smaller the aperture, the less light you're letting in. The wider the aperture, the less depth of field you get. The smaller the aperture, the more depth of field you get.

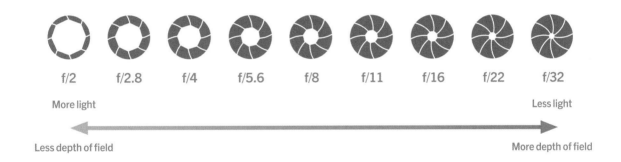

Here's another question:
What is depth of field in photography?

Write down what you think the answer is.

 Answer

Depth of field is the amount of distance in an image that is sharp. I ask the question because a lot of people think it's what's in focus and it's not. Your focus point is your focus point. Depth of field is the distance around your focus point that is sharp.

Depth of field is controlled by three things. The first is the aperture. Again, the smaller the aperture, the larger the depth of field. The bigger the aperture, the shallower the depth of field.

In these diagrams, the purple square represents the focus point, and the shaded area is the depth of field around that focus point.

Right: This illustration represents f/2.8. A big aperture like this gives a shallow depth of field. A very short distance around your focus point will be sharp, while the rest will be blurred.

Right: This one represents f/5.6, a medium aperture. You can see the focus point is the same, but the distance around her that is sharp has increased. In other words, the depth of field has increased.

Right: This illustration represents f/16, a small aperture. This will give you a large depth of field, meaning more distance around your focus point will be sharp.

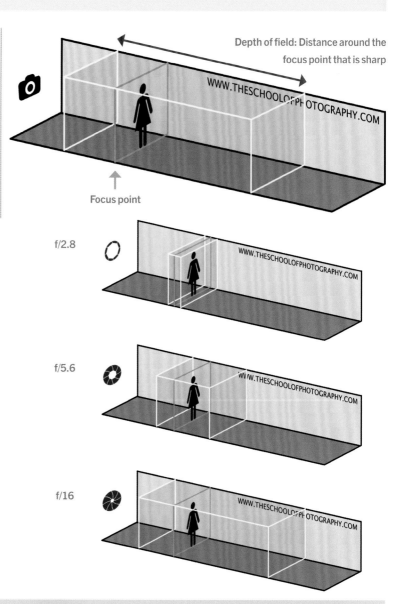

Depth of field: Distance around the focus point that is sharp

Focus point

f/2.8

f/5.6

f/16

Task #11

Control 'depth of field' using apertures.

This task is to get you used to working with apertures and to get you to physically see the effect they have on an image. Setting your camera as per these instructions has been covered in previous chapters, so please refer back if you need to.

1. Put your camera on its Aperture-priority setting (Av or A).

2. Set your ISO to Auto.

3. Make sure your AF point is set to centre frame.

4. Set your camera's lens to a focal length of around 35–50mm.

5. You also need to set your camera up on a tripod and have it set to its 2-second timer. Alternatively, use a remote trigger so the camera stays in the same place and doesn't move during exposures.

Now for some maths!

6 Find a long wall or fence and make sure there's a lot of light – daytime is ideal.

7. Look down the fence/wall at an angle and find a focus point. Make sure that your focus point stays the same in each shot and that your camera is firmly attached to the tripod, as it needs to be absolutely still.

8. Take shots going through your apertures in the numbers mentioned previously in this chapter (see page 75). Different lenses may not have all the numbers shown, so simply use the ones you have on your lens.

9. Compare the shots to see the differences in depth of field – it's best to view them on a computer screen.

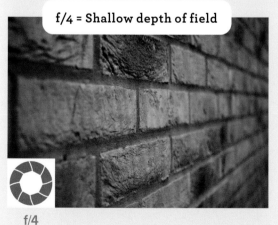

f/4 = Shallow depth of field

f/4

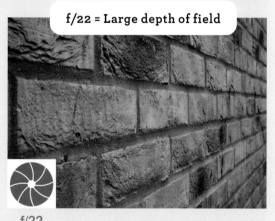

f/22 = Large depth of field

f/22

Example: Notice the difference in the depth of field between all of the shots.

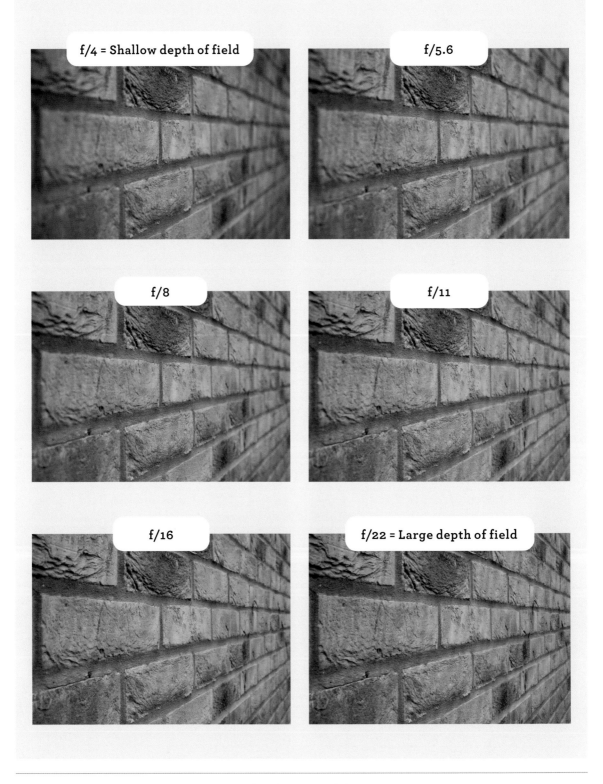

f/4 = Shallow depth of field

f/5.6

f/8

f/11

f/16

f/22 = Large depth of field

Now for some maths!

There are another two elements that control depth of field, one of them being the focal length that you use. We've already done a whole section on lenses and focal lengths, so refer back to that chapter if you need to. In short, it is how zoomed in or zoomed out you are. It's really simple to understand: the more zoomed in you are, the shallower the depth of field you can create; the more zoomed out you are, the larger the depth of field you can create.

A way to prove this is to think of landscape shots, which are normally taken at wide angles, or zoomed out. They are sharp from the foreground to the background, which is a large depth of field.

Portrait shots, on the other hand, are generally zoomed in more, which helps make the background blurry, giving the image a shallow depth of field.

Task #12

Control depth of field using the lens's focal length.

1. Keep your camera on the same settings as before, but this time set your camera's aperture to f/5.6.
2. Zoom out as far as your lens can and take a picture of the same fence/wall.
3. Then zoom in as far as you can and take the same picture with the same aperture. Compare the two shots.

Focal length 24mm / Aperture f/5.6
Wide angle
Large depth of field (symbolized by red arrow)

Focal length 105mm / Aperture f/5.6
Zoomed in
Shallow depth of field

The third thing that controls depth of field is the distance between your focus point and your lens. If your focus point is close to your lens, you will get a shallower depth of field. If your focus point is far away from your lens, you will get a larger depth of field.

Here are a couple of examples:

Both of these pictures were taken with an aperture of f/2.8 and a focal length of 50mm. The only thing that's different is the distance of the focus point.

Left: **The focus point is in the distance, which gives a larger depth of field.**

Left: **The focus point is close to the lens, which gives a shallower depth of field.**

Task #13

Control depth of field using the distance between the focus point and your lens.

1. Keep your camera on the same settings as before, but set the lens's focal length to 50mm.

2. Keeping your camera on a tripod, take a picture of the same fence/wall and make sure you are as close as you can be while still keeping it in focus.
3. Walk backwards a few steps so that the focus point is now further away and take another shot.
4. Compare the two images.

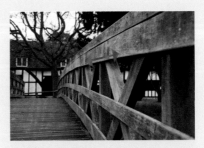

Focal length 50mm / Aperture f/5.6
Focus point is close to lens
Shallow depth of field (symbolized by red arrow)

Focal length 50mm / Aperture f/5.6
Focus point is further from lens
Larger depth of field

Let's look at some examples of controlling depth of field. These two shots were taken 30 seconds apart, but both give totally different results. The first picture was taken using a focal length of 16mm, the aperture used was f/16 and the focus point was in the distance. What you can see is the whole picture from the foreground to the background is sharp, showing a large depth of field.

The second picture was taken with a focal length of 85mm, an aperture of f/2.8 and the focus point was really close to the lens. You can see this has given a really shallow depth of field.

Large depth of field
Aperture: f/16
Focal length: 16mm
Focus point far away

Shallow depth of field
Aperture: f/2.8
Focal length: 85mm
Focus point close to lens

At this point in your learning, you can start to take more control of your imagery by combining your knowledge. In this photo (right), I have demonstrated a combination of the different techniques you've learned so far.

- The focal length was 85mm and the aperture used was f/2.8. This has given me a shallow depth of field.
- I focused on the face, then – while holding the focus – reframed to get the focus point where I wanted it to be.
- I've used a composition where the slats of the beach hut lead the viewer's eye into the model (leading lines).
- As it was a bright day, I used an ISO of 100 to give me as little noise as possible.

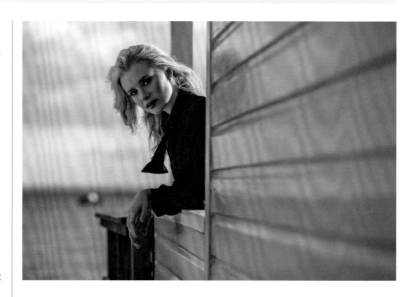

I have also used lighting and shutter speed techniques, which we will get to later in the book. Try to realize how many techniques you are now using in combination to get your shots.

Apertures & depth of field recap

Let's recap on this chapter:

- An aperture is a hole in your lens. The bigger the hole, the more light is let in. The smaller the hole, the less light is let in, just like the pupil in your eye.

- Apertures are displayed as a series of numbers with the letter 'f' in front of them.

- Try to remember the aperture sequence we've spoken about, which indicates whole stops, and ignore the in-between numbers, which are called 1/3 stops, for now.

- The A or Av setting on your camera is called Aperture priority. On this setting, you can control the aperture and let the camera do the rest.

- When you go from one aperture to the next, you are halving or doubling the light. This is why you stick to the aperture sequence I have given you – it will be the same on every camera.

- The higher the f/number, the smaller the aperture. The lower the f/number, the larger the aperture.

- Going from one number to the next is called a stop. If you're letting in more light, it's called a stop up. If you're letting in less light, it's called a stop down. While you're learning, the best thing to do is think about the amount of light that you need first – do you need more or less light? – then attach the number afterwards.

- Depth of field is the amount of distance that is sharp around your focus point.

- There are three things that control depth of field, the main one being the aperture. A big aperture such as f/2.8 will give you a shallow depth of field. A small aperture such as f/16 will give you a large depth of field.

- Your focal length also controls depth of field. The more zoomed out you are, the more depth of field you'll get. The more zoomed in you are, the less depth of field you'll get.

- The distance between your lens and focus point also controls depth of field. The closer the focus point, the shallower the depth of field. The further away your focus point, the larger the depth of field.

 To view a video tutorial on using aperture, go to **www.theschoolof photography.com** and type 'aperture' in the search bar.

| f/2 | f/2.8 | f/4 | f/5.6 | f/8 | f/11 | f/16 | f/22 | f/32 |

More light Less light

Less depth of field More depth of field

10

In this chapter, we're going to look at shutter speeds, but before we do, I want to recap on what exposure is in photography.

An exposure is the amount of light you expose your digital sensor to. An exposure is made up of an aperture, which we looked at in the previous chapter, and a shutter speed setting. For example, 1/60 second at f/8. The aperture is the f/number. A shutter's job is to let light into the camera over a period of time.

The camera body houses the shutter – overleaf are two pictures showing a shutter open and closed.

Shutter speeds

Task #14

Before we get started, I want you to set your camera to the S or Tv setting (Shutter priority) and change your shutter speed by turning the dial on your camera.

Set your ISO to Auto and take a few shots at different shutter speeds. This is just to get you used to the setting and the difference in the shots.

In this setting, you set the shutter speed while your camera automatically changes the aperture and ISO to give a correct exposure (if you have your ISO on Auto).

Below is a guide on how to do this on common cameras. If you get stuck, refer to your camera's manual under 'shutter priority'.

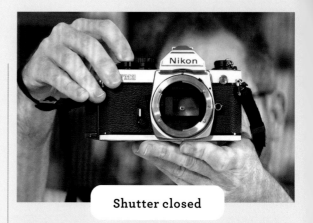

Shutter closed

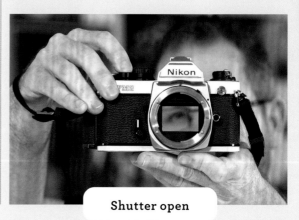

Shutter open

Canon

▓ Turn your wheel to the Tv position.
▓ Make sure your ISO is set to Auto.
▓ Move the dial on top of your camera to change the shutter speed.
▓ You should see the shutter speed changing.

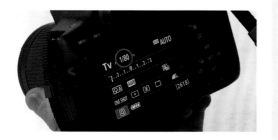

Nikon

▓ Turn your wheel to the S position.
▓ Again, make sure your ISO is set to Auto for this task.
▓ Then move the dial at the back or front of your camera to change the shutter speed.
▓ You should see the shutter speed changing.

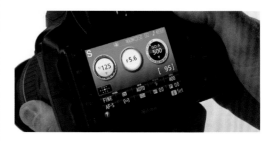

The easiest way to think about shutter speeds is to think about them as fractions. Here's a whole second.

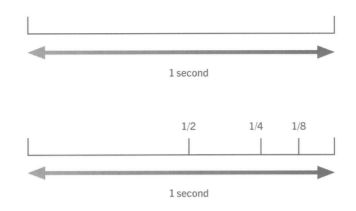

If we split that second in half, we have half a second each side. If we split that again, we have quarter of a second each side and so on. A shutter speed is a fraction of a second or whole seconds.

Here is a typical shutter sequence found on SLR cameras. What you can see here is 1 second, 1/2 second, 1/4 second, 1/8 second, 1/15 second and so on. At 1 second, you're letting in lots of light (this is a slow shutter speed). At 1/1000 second, you're letting in less light (this is a fast shutter speed).

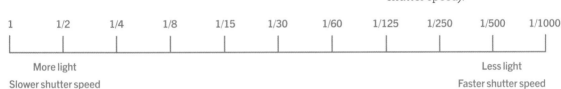

Those good at maths might be looking at the shutter speed sequence and thinking something is wrong in a few places. You can see it goes 1 second, 1/2 second, 1/4 second, 1/8 second, and these are all halving. But then it jumps to 1/15 second, which doesn't make sense because half of 1/8 is 1/16.

This is another confusing thing that photography does. Because if you jump from 1/8 to 1/16 it becomes harder to work out the next fractions, 1/16 is changed to 1/15, which makes it easier to halve again. So, you go from 1/15 to 1/30 to 1/60, and there you can see it changes again for the same reason, going to 1/125 instead of 1/120 because it makes it easier to halve and halve again.

If you're wondering why the numbers are doubling but I'm saying halving, this is because when it comes to exposure, it's about light and it's really important to understand that. By 'doubling' the fraction, we're halving the amount of light coming into the camera. We'll be coming back to this and putting it into practice a bit later, so don't worry too much if it's confusing you for now.

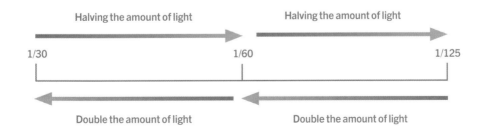

Shutter speed basics

The way shutter speeds are displayed on cameras can also be quite confusing, as different camera models show these settings in different ways. Let's take 1/60 second to start with. On most cameras, it will be displayed as 1/60, but on some cameras, it can be displayed as just 60. Then when you go from fractions of a second into seconds, you will see a number displayed with the quote symbol: **"**

So, if you see 1", this means 1 second. If you see 2", this means 2 seconds and so on.

On some cameras, you might see ½ displayed as the half fraction, which makes sense. On other cameras, you will see half a second displayed as 0"5, which means 0.5 seconds. This can be really confusing, but the basic rule is when you see a number followed by a **"**, you are in seconds rather than fractions of a second.

When you see zero followed by a **"**, you are in fractions of a second. So, the camera can show 0"5, which is 0.5 seconds, 0"3,

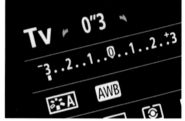

which is 0.3 seconds, and so on.

OK, so if you haven't had enough of maths yet, I've got some more for you. If you remember in chapter 9, we talked about stops. A stop in photography is either halving or doubling the amount of light. The same thing happens with shutter speeds. Have a look at this diagram (right).

We have 1/60 second in the middle. If we double the amount of light, we go to 1/30 second and if we halve the amount of light again, we go to 1/125 second. It gets confusing because the number is decreasing but the

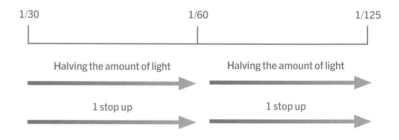

light is increasing. As with aperture numbers, it's all opposite.

When I was learning photography as a young student in the 1990s, all this really did confuse me, all these numbers and maths!

But I came to the conclusion that photography is back to front: the numbers are simply back to front compared to what actually happens to the light. If you start to think like that, it may help you to understand exposure better.

Camera shake

If you go below 1/60 second when you are handholding your camera, you're likely to get what is called camera shake. This means the image will blur. Higher focal lengths (zoomed in) will also increase the likelihood of camera shake. To avoid this, use faster shutter speeds or a tripod.

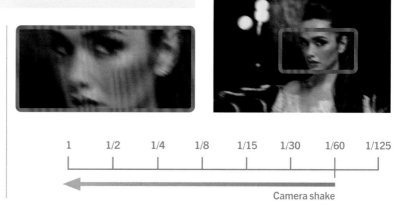

| 1 | 1/2 | 1/4 | 1/8 | 1/15 | 1/30 | 1/60 | 1/125 |

Camera shake

Freeze action

When you go above 1/125 second, you're creating faster shutter speeds.

Faster shutter speeds are used to freeze the action.

On the right, we have an image taken at 1/500 second. On the far right, we have an image taken at 1/8 second.

As you can see, the one on the left is sharp and the action has been frozen. That's because the shutter speed is faster.

The one on the right is blurred (camera shake). This is because the photo has been taken at a slower shutter speed. In other words, the light entered the camera at a slower rate while the camera was moving.

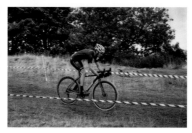

1/500 second – f/2.8 – ISO 100

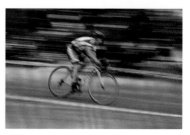

1/8 second – f/22 – ISO 100

Also, notice here that the aperture has changed. The one on the left is a wider aperture while the one on the right is a smaller aperture. That's to balance out the amount of light coming into your camera.

As you let less light in with the shutter speed, you need to let more light in with the aperture and vice versa. We will cover this balancing of exposure in more detail later on. I just want you to notice it for now.

Task #15

Let's look at some more examples. Here are four pictures that all show creative use of shutter speed.

Which ones do you think have been taken with a longer shutter speed and which ones have been taken with a faster shutter speed? How can you tell? Jot down some notes.

Shutter speed basics

■ I think you'll agree that these two pictures (above) have been taken with a faster shutter speed.

You can see this because the action in the images has been frozen. You can only do this using very fast shutter speeds.

■ This one is a bit of trick question because there's nothing in the image above that's moving. However, this shot has been taken using a slow shutter speed.

You can tell this is a long exposure because of the way the street lights have formed a star formation. When you shoot a long exposure and there are lights in the scene, they bleed out into your picture and create this lovely star effect.

■ Then you have the picture of a busy road. This has been taken using a longer shutter speed. You can see this because the road is still but the cars are moving. The lights on the cars travel through the frame, as they are the only things moving.

The reason you can see only the cars moving is because this picture has been taken using a tripod.

When you take a picture with a slow shutter speed and the camera is attached to a tripod, everything that is still stays still, and everything that moves – in this case the car lights – blurs.

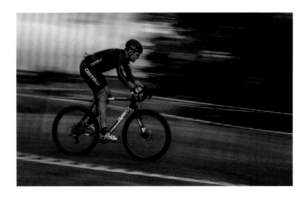

Here's another example of how you can use shutter speeds to create interesting effects (above left). This is called panning. In panning, you follow the moving object with your camera, which keeps the moving object still while the background blurs.

Here's another example of how you can get creative with shutter speeds (above right). This shot is a long exposure, but the person in the middle has stood still while everyone around him is moving.

Again, anything moving has become blurred and anything still has stayed sharp.

Task #16

Set your camera to the S or Tv setting. Then, because we are going to be shooting moving objects, we're going to change the focusing mode so it can track moving subjects. We're also going to change the drive mode to continuous shooting to make sure

we get the shot. Below is a guide on how to do this on common cameras. Simply refer to your camera manual under 'continuous servo' or 'AI Servo' and 'drive modes'.

Canon

To change the focusing mode:
▪ Press the Q button.
▪ Select the One Shot area on the screen
▪ Select AI Servo.

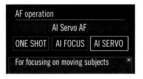

To change the shooting mode:
▪ Press Q again then go over to the square symbol that says 'Single shooting'.
▪ Select 'Continuous shooting'.

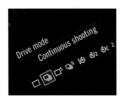

Nikon

▪ Press the ℹ️ button.
▪ Go to Focus mode and select AF-C.
▪ Press the Shooting mode button and select Continuous.

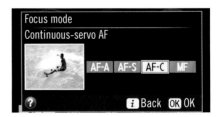

Task #16 cont.

Control the movement in your shots.

OK, the first task is very simple: I want you to freeze the action of something moving. This could be a jogger, a moving car, a cyclist, etc.

1. Change the focusing mode and drive mode as mentioned on the previous page.
2. Put your ISO on Auto.

3. Make sure your focus point is set to centre frame (as shown in chapter 4).
4. Take a shot of the moving subject using the shutter speeds below.
5. Compare the shots to see which shutter speeds have frozen the moving subject.

In this task, I want you to see the effect a shutter speed has on a moving object and get you working around your camera so you can start to control shutter speeds.

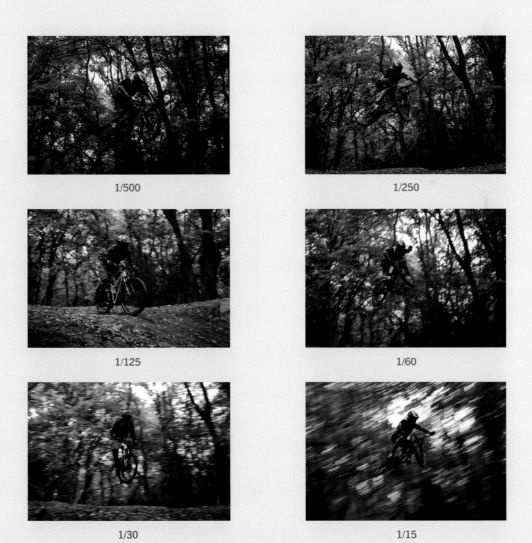

1/500	1/250
1/125	1/60
1/30	1/15

So, hopefully you had fun with that. As I said before, it's just to get you working with your shutter speed settings and getting you to recognize the effect shutter speeds can have on moving objects.

Task #17

Panning – setting up your tripod

The next task I want you to try is a technique called panning. You're going to need a tripod for this, and you need to make sure your camera is securely attached to it, otherwise this task will not work.

Make sure the lens points away from you and a handle comes towards you as shown right.

1. On the tripod, loosen what's called the 'pan lock'. It's usually located on the side of most tripods.
2. Once loosened, you should be able to pan left and right freely.

Panning

Panning is where you move the camera at the same speed as a moving object, 'freezing' the moving object while blurring the background, creating a sense of speed. Getting set up for panning isn't too hard – getting your camera to move at the same speed as the moving subject is the difficult bit!

Take pictures of a moving subject – someone walking, riding a bike etc. – and try to keep them still in the image while the background blurs. Start this task using a tripod, then try it handheld.

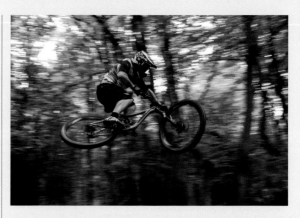

1/60 second

1. Set your camera to 1/8 second.
2. Make sure your focus point is centre frame and your ISO is on Auto as in the previous task.
3. Focus on the subject and hold the focus by half-pressing the shutter button down as shown in the chapter 4.
4. Pan the camera on the tripod so it moves at the same speed as the subject, then take the shot. Getting this right first time is rare so keep practising until you get it.

5. You can also do this task handheld, so if using a tripod becomes difficult, try it handheld instead.
6. Try the same thing again at different shutter speeds. There is no 'one setting fits all' with panning.

Objects moving at different speeds will require different shutter speeds to get the desired effect.

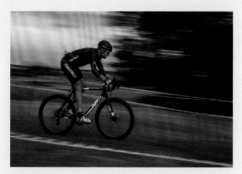

1/15 second

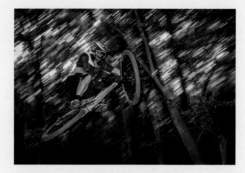

1/15 second with flash

So, there is your panning task. It's a really good technique and lots of fun to try, but quite hard to master.

Faster objects will need faster shutter speeds and you can't actually judge that until you are in situ. Practise your panning technique, then we'll look at some more stuff you can do with shutter speeds.

This picture shows the same technique, but a burst of flash has gone off during the exposure. This is a technique called 'slow sync flash'. Simply pop up your flash or use a flashgun to get this effect.

▶ To view a video tutorial on panning and slow sync flash, go to **www.theschoolofphotography.com** and type 'slow sync flash' in the search bar.

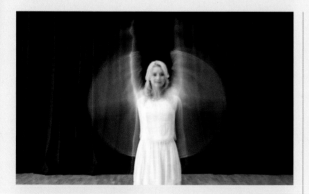

Task #18

Here are some more tasks you can do to push your use of shutter speeds further.

You can do these with your kids, friends or family and they're really fun activities to try while learning about shutter speeds.

The first task is to give a model wings. First, set your camera up on a tripod and turn the wheel to Tv/S mode with your ISO on Auto. Get your model to move their arms up and down while you take the shot. Start at 1/2 second then experiment – go up to 1 second and 2 seconds, or use faster shutter speeds if you want to. It's up to you!

Task #19

You can also use slow shutter speeds while zooming in and out.

1. Set your shutter speed to 1/2 second and put the focus point in the middle of the eyes.

2. Take a shot while zooming in or out. This will create a really surreal effect and is great fun.

You can also add some flash into the shot. If you have a flashgun, this will work really well, but you can also use your pop-up flash too. Simply do the same as the above but with your flash popped up or your flashgun on.

Zooming in

Zooming out

Zooming in with flash

Zooming out with flash

Task #20

The next task involves water balloons!

As before, make sure you're on Tv or S for Shutter priority, and set your ISO to Auto.

1. To capture the water balloon bursting, you need to set your shutter speed to 1/250 second or faster.
2. Set your drive mode to continuous shooting.
3. Put the focus point where the balloon is going to burst, then switch to manual focus on your lens to hold the focus on that spot. If you don't do this, it's likely the camera will try to autofocus on different parts of the scene as the balloon bursts.
4. Start taking shots just before the balloon bursts and you should catch it.

It might take a few attempts, but it's a great task to try on a sunny day.

Once you've done all that, you've started to take control of your shutter speeds. To challenge your skills further, make images that show creative use of shutter speeds. What else can you do with these techniques? This will really cement the learning and you'll have some fun while doing it.

And don't forget, we always like to see students' work here at The School of Photography. So, if you want to show us yours, tag your best shots on social media **#theschoolofphotography**

Have a good practice with those tasks and when you're ready I'll see you in the next chapter.

Above: **Taken with a shutter speed of 8 seconds**

exposures

Balancing exposures

In this chapter, we're going to start putting things together and look at how we balance exposure to create different visual effects.

We've learned about apertures, we've learned about shutter speeds and we've learned about ISO. Now we're going to look at how we balance exposure, as this is what distinguishes a photographer from someone who just picks up a camera and goes 'click'.

A photographer will be able to balance light coming into the camera to get a certain visual effect.

Remember that an exposure in photography is letting in an amount of light. An exposure to light is made up of your aperture and your shutter speed. You are doubling or halving the amount of light when changing your shutter speed or aperture. These are called stops. Don't forget that you should be using the aperture sequence that I showed you earlier in the book (see page 75).

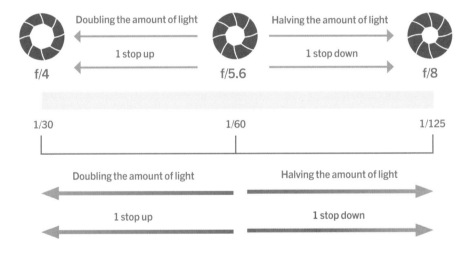

Your job as a photographer is to balance light via the shutter speed and aperture to get the visual effect that you want. To help you understand this, I want you to imagine light as weight. This scale represents the exposure of an image, the left part being the light let through the aperture and the right part being the light let in via the shutter speed.

The weights below represent the correct exposure (amount of light) I need – 600g in this case.

In Auto mode, your camera will try to let the light into your camera as evenly as it can.

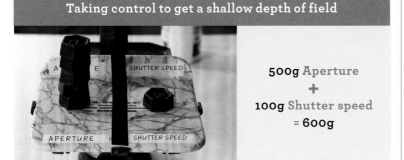

Auto mode

300g Aperture
+
300g Shutter speed
= **600g**

Taking control to get a shallow depth of field

500g Aperture
+
100g Shutter speed
= **600g**

Same exposure to light – two different visual effects

In this case, we have 300g on the aperture and 300g on the shutter speed.

Now, as a photographer, you should be taking control of the light. We've only got 600g of weight to play with (our available light). Let's say I want to create a shallow depth of field – for this, I will need a wide aperture.

A wide aperture is going to let a lot of light into the camera, so to compensate for this, I need to let less light through the shutter speed to give us the same exposure as before (600g).

Therefore, 500g has gone on the aperture and, to compensate, only 100g on the shutter speed side.

This is now equal to the correct exposure (600g), but giving a totally different visual effect.

Now let's say I want to create a sense of movement in a photo. For this, we'll need a slow shutter speed and therefore most of our available light (600g) is going to come through the shutter speed.

To balance the exposure, I need to let most of the light through via the shutter speed (500g) and only a small amount of light via the aperture (100g). This is still the correct exposure, but again a completely different visual effect.

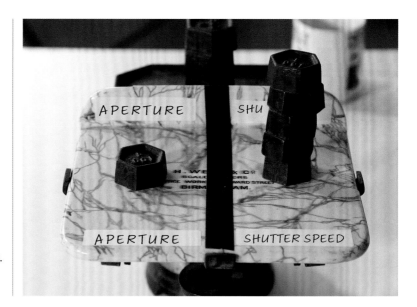

Auto mode	Shallow depth of field	Creating movement
300g Aperture	**500g** Aperture	**100g** Aperture
+	**+**	**+**
300g Shutter speed	**100g** Shutter speed	**500g** Shutter speed
= 600g	**= 600g**	**= 600g**

Same exposure to light – three different visual effects

Another way to show you this balancing of exposure is to use water to demonstrate how the shutter speed changes when you change the aperture.

On the left, I have a wide funnel representing an aperture of f/2.8.

On the right, I have a small funnel representing an aperture of f/16.

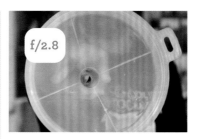

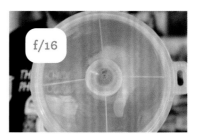

And here I have two 500ml jugs of water that represent the amount of available light.

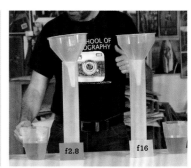

Exposure basics

If I pour the jugs of water into the funnels at the same time, the time taken for the cylinders to fill up is different. This represents the shutter speed.

The left cylinder (the wide aperture) has let in the water (light) very quickly. This means that the shutter speed for the wide aperture needs to be fast.

However, the cylinder on the right (the small aperture) has let in the water (light) very slowly. This means that the shutter speed for the small aperture needs to be long.

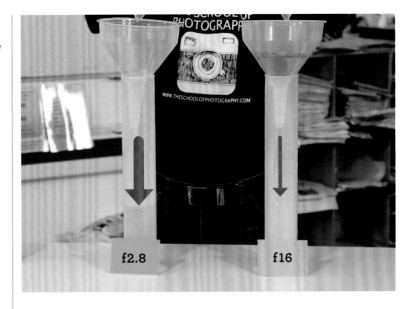

Now I'm going to give you a maths test. I want to do this just to cement this knowledge of how to balance exposure. It might seem difficult at first, but once you get it, I promise it will all sink in and make things a lot better for you in the future.

So, in true maths lesson style, here's a question:

Question: An exposure for a shot of a person is 1/60 second at f/8. This is the correct amount of light the camera needs for the current lighting conditions. In Auto mode, this is the exposure the camera is showing.

Answer overleaf

As a photographer, I want to control the visual effect of the image and create a shallow depth of field so the background goes blurry, so I change the aperture to **f/2.8**.

What does the shutter speed need to be to expose the camera to the same amount of light?

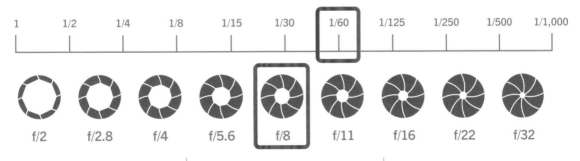

Remember, this is a balancing act. By changing the aperture from f/8 to f/2.8, I have increased the amount of light entering the camera and therefore must compensate with the shutter speed. Take a few minutes to think about this, then write down an answer on your notepad.

Answer
Here's how you should have worked it out. Remember the balancing act, remember the scales.

We started at f/8, as that's what the camera gave us to work with. I wanted a shallow depth of field and for that you need a wide aperture, so I went from f/8 to

f/2.8, increasing the light via the aperture by 3 stops.

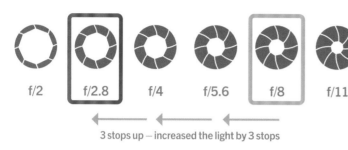

So, I need to make the exposure 3 stops darker via the shutter speed to balance out the light. If I don't, I'll get an overexposed shot. The original shutter speed was 1/60 second and I need to go 3 stops darker. I go to 1/125 second (1 stop darker), 1/250 second (2 stops

darker) and 1/500 second (3 stops darker). I've now balanced out the exposure to give me the same amount of light.

The correct answer is **1/500 second.**

Both of these exposures are letting in the same amount of light, but they are giving two totally different visual effects.

Let's do another question, as I know you've not had enough yet!

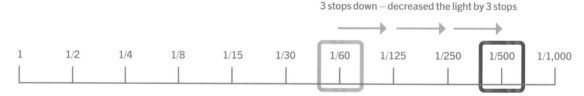

Question: Let's keep to the original exposure of 1/60 second at f/8 with this next question. This is the camera just giving an automatic exposure. This time, however, I want to create a sense of movement, so I set the shutter speed to **1/15** second, which will give me that blurred look.

What does the aperture need to be to expose the camera to the same amount of light?

Refer to the aperture and shutter speed sequences, then write down an answer in your notebook.

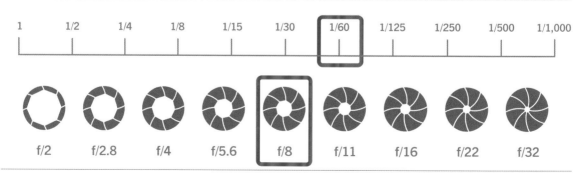

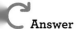 **Answer**

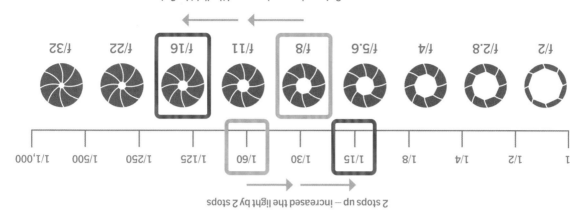

2 stops down — decreased the light by 2 stops

| f/32 | f/22 | f/16 | f/11 | f/8 | f/5.6 | f/4 | f/2.8 | f/2 |

| 1/1,000 | 1/500 | 1/250 | 1/125 | 1/60 | 1/30 | 1/15 | 1/8 | 1/4 | 1/2 | 1 |

2 stops up — increased the light by 2 stops

Let's go through the answer. The original exposure was 1/60 second at f/8, but I have moved the shutter speed to 1/15 second, which is 2 stops brighter.

The original aperture was f/8, so I need to balance the light by making the aperture 2 stops darker.

So, I go to f/11 (1 stop darker) then to f/16 (2 stops darker). **The answer is f/16.**

Hopefully, you should be getting there, but just in case, here's one more. I want you to correct the exposures below to give the same amount of light. The base exposure is 1/125 second at f/5.6.

On the first one I've changed the aperture to f/16, so you need to change the shutter speed to balance it out and give the same amount of light. On the second one I've changed the shutter speed to 1/500 second, so you

need to change the aperture to give the same amount of light as the base exposure.

Have a think and write your answers in your notebook.

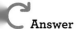 **Answer overleaf**

Base exposure: 1/125 second at f /5.6

_____ at f/16

1/500 second at _____

| 1 | 1/2 | 1/4 | 1/8 | 1/15 | 1/30 | 1/60 | 1/125 | 1/250 | 1/500 | 1/1,000 |

| f/2 | f/2.8 | f/4 | f/5.6 | f/8 | f/11 | f/16 | f/22 | f/32 |

Answer

The first answer is 1/15 second and the second answer is f/2.8. Hopefully, you got these right. If you didn't, I recommend you read back over the last few pages until you understand it.

All these exposures let the same amount of light into the camera. However, each one will give a different visual effect.

Base exposure: 1/125 second at f/5.6

1/15 at f/16

1/500 second at _f/2.8_

Photographers control the visual effects of their images by balancing light. This is really important to know. Balancing exposures for different visual effects is what makes you a photographer as opposed to someone who just snaps away in Auto. Now I'm going to set you a task to get you out there and practising in fully manual mode.

Task #21

Use fully manual mode to control the visual effects of your photographs.

1. Take two pictures of the same thing showing two different visual effects.
2. Twist the dial at the top to the 'M' position.
3. Set your ISO to 400. If it's a very bright day, set the ISO to 100.
4. Set your camera up on a tripod and use a remote trigger or 2-second timer.
5. Expose each picture correctly by making sure your exposure meter is on '0' for each shot. You do this by changing the shutter speed and aperture.

On the next page is a guide to how to expose for shots in fully manual mode on popular cameras. Most other cameras work in a very similar way. If you get stuck, simply refer to your camera's manual under 'manual mode'.

Try to create the following effects:
· Large depth of field and shallow depth of field
· Motion blur and a still shot

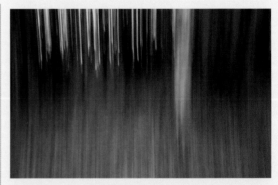

f/8 – 1/2 second – ISO 400

f/1.4 – 1/60 second – ISO 400

Canon

- To manually change your shutter speed, twist the dial on the top of your camera.
- To change the aperture, press and hold the Av button (+/- button) while twisting the dial on top.
- Some Canon cameras have a second circular dial on the back to change the aperture.
- Keep changing the shutter speed or the aperture until the meter reaches the centre '0' (pictured below).

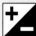 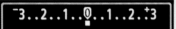

Nikon

- Make sure you take your ISO off Auto, then set it to 400, or 100 if it's a very bright day.
- Twist the dial on the back of the camera to change the shutter speed.
- To change the aperture, hold down the Exposure Compensation button (+/- button) or the button with the aperture symbol while twisting the same dial. You should see the meter on your screen change. Some cameras have a second circular dial on the front to change the aperture.
- Keep changing the shutter speed or the aperture until the meter reaches the centre '0' (pictured below).

When in the M mode, if you press the shutter halfway down, you'll take a meter reading (the camera will measure the light available). The camera's light meter (highlighted red and yellow above) will show a dot/line going into – or + numbers. This is your meter reading. If the dot is in the + numbers, your exposure is currently overexposed. If the dot is in the – numbers, your exposure is underexposed.

You need to change the aperture and/or shutter speed accordingly to get that dot onto '0'. When the meter reading is '0', you are correctly exposed for the shot.

In photography, you should always start with the visual effect you want to achieve. For example, if you want to create a sense of motion blur, you know you will need a slow shutter speed, so you start there and work the rest of the exposure around that. Keep repeating this task until you have full control over the visual effects of your photography.

 To view a video tutorial on getting this blurred look, go to **www.theschoolof photography.com** and type 'ICM' in the search bar.

Same amount of light – two different visual effects

f/8 – 1/2 second – ISO 400

f/1.4 – 1/60 second – ISO 400

Above: **I've panned upwards on my tripod while taking the shot at a slower shutter speed. The slower shutter speed has blurred the shot whereas the faster one hasn't.**

f/2.8 – 1/60 second – ISO 400

f/22 – 1" – ISO 400

Above: **In this example, I have changed the aperture in the two shots to give me a shallow depth of field in one and a large depth of field in the other.**

How ISO affects exposure

I hope you've had a good practice with that; it's a really good task to help you understand that balance of light. Now let's talk about where ISO fits into all of this, because ISO also affects the exposure.

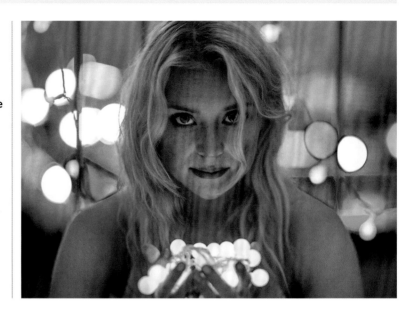

When you're doing any shoot, as stated before, your starting point is deciding what visual effect you want. For instance, do you want to create a shallow depth of field? If so, a wide aperture is needed (right).

Or do you want car headlights streaking off into the distance? For that, you need to use slow shutter speeds (left). These are the things that give you the visual effect.

So where does ISO fit into all of this?

ISO doesn't make the cars streak off into the distance – a slow shutter speed does that. ISO doesn't create a shallow depth of field – your aperture does that.

As shown in chapter 8 you ideally want as low an ISO as possible in all your shots, as this will reduce noise and give you a higher-quality image. But the real world doesn't work like that. You might be inside or outside, the sky might be sunny or cloudy etc. So, you need to think about what

ISO setting you need after you've thought about what visual effect you want.

Always start with what visual effect you want and work your exposure settings around that.

Let's say you're inside a building and you want to take pictures of people. You're handholding the camera and the visual effect that you want is sharp people with no blurring.

For this, you need a fast shutter speed, so this is your starting point. A shutter speed of 1/125 second will be fine here. Then you might select your widest aperture – let's say f/4 – to let in as much light as possible.

In this situation, your setting to get that visual effect is 1/125 second at f/4.

That still might not let in enough light to enable you to use a low ISO. In this case, you will need to up the ISO to make the camera's sensor more sensitive to light. This will enable you to get a shot with a faster shutter speed in low light. The trade-off for this, though, is that you will get some noise in your image, but you will also get a sharp picture.

You're limited by the light you have available in photography and that's that. There's nothing you can do about it other than control it coming into your camera as best you can.

Think back to the first chapter of this book – photography is about controlling light.

1/125 second – f/4 – ISO 1,600

Left & above: **Increasing the ISO setting will result in more noise visible in your images.**

Above is a perfect example of this. A low-light situation, but you want to capture the scene without any movement. You use a shutter speed of 1/125 second and your lens's widest aperture, in this case f/4. There is not enough light to use a low ISO, so you up the ISO to 1,600 to make the camera more sensitive to light instead. In this situation you're able to freeze movement in low light by increasing the camera's ISO setting. The trade-off for this, however, is that the image will have noise.

I know that balancing exposures can be quite complicated to get your head around and I recommend that if you haven't quite got it, read this chapter again, get out there with your camera and use it in fully manual mode. Control the image effect that you want. Sometimes it's much better to just give it a go and get practising with it. Once you're good with all of that, move on to the next chapter.

Resolution

Resolution basics

This chapter is about resolution and how it can benefit you as a photographer.

Resolution, sometimes called the image res, is the amount of pixels an image has. A pixel is the smallest part of a digital image. If you've ever zoomed in on an image, you will have seen that it turns into lots of little squares – those squares are the pixels.

The resolution of an image is the total number of pixels within it. Resolution comes into effect when you want to print images. To get big prints, you need a high-resolution image. For instance, if you want a 10x15in print, you're going to need your camera set to its highest resolution, as you're going to want as many pixels as possible in the image.

If you're never going to print a picture and it's just, for example, for an internet auction site, for example, then you will just need a low-resolution image. There's more about that further on in this chapter, but first let's have a look at what a low-resolution image looks like against a high-resolution image.

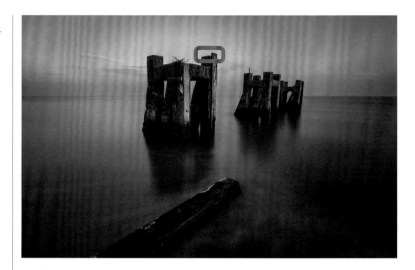

Below we have two versions of the same picture. One has been taken with a high resolution and the other has been adjusted so it has a very low resolution.

You can see that the low-resolution version is blurry. This is what's called a 'pixelated' image.

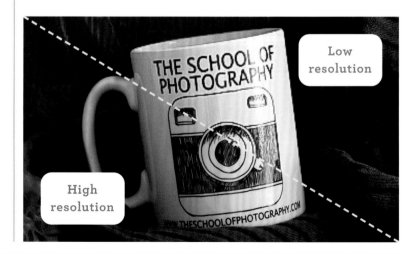

Low resolution

High resolution

THE SCHOOL OF PHOTOGRAPHY

WWW.THESCHOOLOFPHOTOGRAPHY.COM

Here are the file sizes of two images taken at different resolutions. The high-resolution image has a file size of nearly 8 megabytes (MB) whereas the low-resolution image has a file size of just over 1MB. To put that into context, you can get roughly eight low-resolution images for your one high-resolution image.

A high-resolution image can stretch out more, which means it can be printed at a larger size. Also, the higher the resolution, the more pixels you have to play with, so if you need to crop into the image, you can still print it with no obvious loss of quality.

You might be thinking, 'I'll just take all my images at high resolution, just in case'. Well, there is a downside to that. It will clog up your camera's memory card quickly, it will use up more of your computer's hard drive and, if you're going to be emailing or uploading images to websites, it's going to take a lot longer for image files to be sent.

That's where low-resolution images come into play. When you want to upload images to websites, share via email or just use less space on your hard drive, it's better to use low-resolution images.

Resolution is quite simply the amount of pixels an image has. The higher the resolution, the more pixels, better for cropping into and printing at size. The lower the resolution, the fewer pixels, better for uploading and emailing.

If you have the fastest computer and loads of space on your hard drive, in theory you could just leave your resolution on high, unless you are going to be emailing your pictures to other people.

Confusion can arise when it comes to camera settings. Some cameras will display resolution as L, M and S, which stands for Large, Medium and Small. Other cameras will display it as megapixels (MP), so you might see something like 8M or 12M etc. Some cameras show both.

A megapixel is one million pixels. To put this into context, if your camera has a 24-megapixel sensor, your image will have 24 million pixels in it.

Some cameras will also display the file size, for instance 10 MB. It all sounds confusing and, quite honestly, it is. It's just down to the different camera brands all doing different things. Try to figure out the way in which your camera displays resolution. This information will be in your camera's manual.

Image quality explained

Just to confuse you even more, cameras have a menu option called JPEG quality, sometimes referred to as Image quality.

So, you have your image size (the resolution of your image) and your image quality, or JPEG quality. Some cameras will show 'smooth arch' and 'jagged arch' symbols as shown in the above right menu example.

A smooth arch means a high-quality JPEG. A jagged arch means a low-quality JPEG.

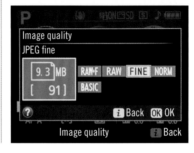

Other cameras will say Fine, Norm, Med and Low as shown in the second menu example.

There's more about JPEGs later on in this chapter, but for now my advice is to leave the JPEG quality on the 'smooth arch' or Fine setting. The only reason you would put it on a lower setting is if you are going to be taking several images to be sent via the internet.

I want to refer to this table stating the resolution (number of pixels) needed for a particular print size.

At the top is 0.5MP. This was the resolution of the first camera phones. On your phone screen, images looked great, but try to print or enlarge them and they looked terrible!

Next we have 2MP. With a 2MP image, you can print a 3x5in print and it will look perfect.

At the bottom of the table, 10MP+ gives you enough pixels to print a 13x17in image.

Resolution needed for various print sizes	
Resolution	Max. print size
0.5 megapixels	N/A
2 megapixels	3 x 5 inches
4 megapixels	5 x 7 inches
6 megapixels	8 x 10 inches
8 megapixels	11 x 14 inches
10+ megapixels	13 x 17 inches

Let's put this into context. How many times are you going to want to print an image that is bigger than 13x17in? If you're producing final prints for a client, for example, you will want the highest resolution possible, but if you're printing holiday snaps

and know that you're not going to print them larger than 8x10in, you only need to have your camera set to 6MP, and on most new cameras that is the lowest setting.

Task #22

Get familiar with your camera's image size and quality settings.

This task is to get you used to where the resolution settings are and help you to figure out what image sizes your camera is going to produce.

Below I'm going to show you how to do this on common cameras. Other models will be very similar. Look up 'image quality' or 'resolution' in your camera's manual if you need help.

1. Set your camera to P.
2. Put your ISO on Auto.
3. Attach your camera to a tripod and use a remote trigger or 2-second timer to make sure your camera stays still during the exposures.
4. Work in JPEG, not Raw. We'll cover Raw later in this book. It's important you get your photography correct first before we look at Raw files. Raw files are for post-processing so we'll stick to shooting in JPEG while we are learning.

High resolution

Low resolution

5. Take two shots of the same thing, one at the lowest resolution and one at the highest resolution.

Then transfer the two images onto a computer and zoom to view the images in more detail. I want you to see the difference between where the high-resolution image looks pixelated and where the low-resolution image looks pixelated.

Canon

▪ Press the Menu button and scroll with your dial until you find Image quality.
▪ In the Image quality menu, you'll see the selection of L, M and S that was mentioned earlier.
▪ Take one photo using the L setting, then another using the S setting.

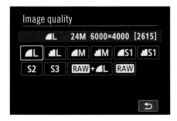

Nikon

▪ Press the **𝒊** button then select Image quality.
▪ Select JPEG fine.
▪ Press the **𝒊** button again and select Image size.
▪ Select L to take one picture at the highest resolution and S to take one at the smallest.

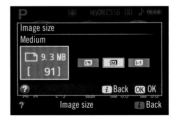

- Taken at a high resolution
- Picture is clear even when zoomed in

- Same picture taken with a low resolution
- Picture is soft when zoomed in – it has become pixelated

All about PPI

Hopefully, you're getting a bit more comfortable with the resolution settings on your camera. The next thing to learn is something called PPI, which stands for pixels per inch.

I'm sure things are getting quite confusing now, what with PPIs, pixels, resolutions, etc., but please don't stress. PPI is something you don't need to worry about too much unless you're working with external print labs or building a

website where you need images to be a particular size and resolution. However, I do feel it's important to go through this, as it might be something that you've come across or will come across in the future.

If you have an image 10in wide and its resolution is 72PPI, this means that there are 72 pixels within a straight line of 1in of the image (right).

On screen it will look fine, as 72PPI is the optimum screen resolution. If the image has more than 72PPI, you will not see any difference. If the image has less than this, it will become pixelated.

Above: **72 pixels within a straight line of 1in of the image.**

72PPI

Above: **10in at 72PPI is optimum screen resolution.**

A print at a resolution of 72PPI
If you try to print an image with 72PPI, it will look like this (pixelated).

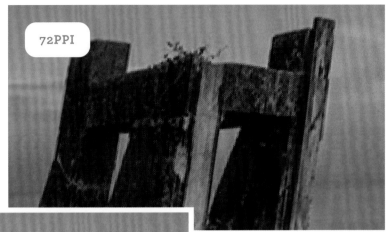

72PPI

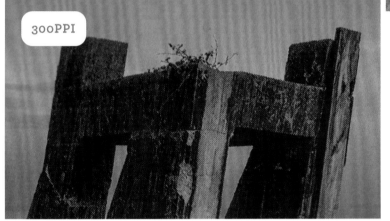

300PPI

A print at a resolution of 300PPI.
To get a print looking perfect, it needs to be at least 300PPI, which is the optimum print resolution. If the image has more than this, you will not see a difference. If the image has less than this, it will become pixelated.

I know it sounds confusing, but that's pretty much all you need to know. For an image to look good on screen, it needs to have at least 72 pixels within 1in. For a picture to look good in print, it needs to have at least 300 pixels within 1in. The reason it needs to be higher in print is because your eye sees a lot more than a screen can project.

Let's recap:
- Resolution is the number of pixels your image has.
- A pixel is the smallest part of a digital image – one square.
- High-resolution images are good for cropping or printing.
- Low-resolution images are good for internet and emailing.
- High-resolution images will have bigger file sizes and will take up more space on your memory card and computer, whereas low-resolution images will have smaller file sizes and will take up less space.
- Resolution settings differ from brand to brand – get to know your camera model's way of doing things.
- A megapixel is one million pixels.
- Set your JPEG or Image quality to its highest setting.
- PPI stands for pixels per inch. Your minimum screen resolution should be 72PPI. Your minimum print resolution should be 300PPI.

13

Understanding light & white balance

See the light

Photography is all about the control of light and here you'll get a better understanding of how light works with photography.

To get us started, I want you to answer this question:

Where does light come from?

That sounds like a really simple question, but I want you to name as many types of light sources as you can.

For example, car headlights are a source of light, a street lamp is a source of light and so on.
I want you to write down as many examples as you can.

Types of light
The fact is there are lots of different light sources available to us, and knowing the effect they have on a picture can really help you out.

I'm now going to put these different light sources into three groups: natural light, flash light and artificial light. Let's look at the variations of light under these headings.

Natural light
Under natural light, you have daylight at noon, which will give you a pure white light.

You have sunsets and sunrises, which will give you orange light (right).

You have cloudy skies, which will add blues into the light (below).

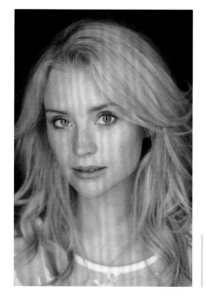

Flash light
Under flash, you get studio lighting, for a more controlled look (left), and flashguns, which are a good source of portable light (above).

Artificial light

Under artificial light, you get something called tungsten lighting, which is commonly found in old light bulbs and will give you an orange light (above right). You also get fluorescent lights, which give off a green cast (above), and street lights, which are generally a yellow/orange colour (right).

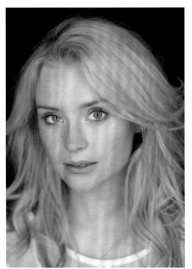

There are loads of different types of light and each one will give you a different look. And it doesn't end there because under every light source, you can get different effects of light.

This basically breaks down into two categories: hard light and soft light.

Hard light

Hard light is created by direct light. This means the light is coming direct from the light source and hitting the object.

Examples of hard light include a sunny day or a flash on a camera and the effect it will show is strong shadows, shiny skin, etc.

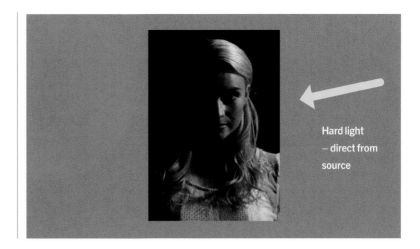

Soft light

Soft light can be created in two different ways. The first is by reflected light where light reflects off a surface and hits the subject.

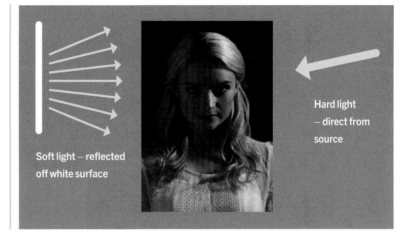

Diffused light

Another type of soft light is called diffused light, which is created when light travels through something.

As you can see, there are loads of different types of light that can give you all sorts of effects in your photography. **Recognize what type of light you have available or what type of effect you want before you start shooting**. That little bit of planning will really help you out.

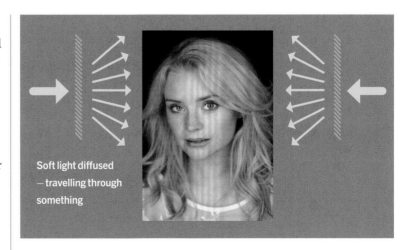

White balance

White balance is all to do with controlling the colour of your light. The easiest way to describe white balance is by way of colour temperature. Colour temperature is a way of measuring the colour of the light source. Right is a white balance table.

On the right of this table are the common symbols you will see on your camera. Under colour temperature, there are numbers which refer to the colour of the light – the K stands for Kelvin. The higher the number, the bluer the light. The lower the number, the more orange the light.

These numbers are something you don't really have to get involved with too much, but what you do have to know is what colour certain light sources produce.

If you hold a piece of white paper in bright daylight, it looks white. When you step into a classroom or office lit by strip lights, to your eye that piece of paper is still white. This is because your brain adjusts to say that this is a white piece of paper. Cameras don't work in the same way – they actually see the colour of light that is being emitted.

WHITE BALANCE SETTINGS			
Light source	Colour of light	Colour temp. (approx.)	Symbol on camera
Shade		7,000K	
Cloudy		6,000K	
Flash		5,500K	
Daylight – noon		5,200K	
Fluorescent		4,000K	
Tungsten		3,200K	

Cloudy		6,000K	

For example, a cloudy day will give you a bluer light.

Daylight – Noon		5,200K	

The sunshine symbol represents daylight at noon. This is pure white light, when the sun is highest in the sky.

Then you go to fluorescent lighting, which is a bit more green.

Fluorescent		4,000K	☀

Tungsten		3,200K	💡

And then you have a light bulb symbol for tungsten light, which emits an orange colour.

Tungsten is a metal and is on the periodic table. It's that little bit of metal that runs through an older type of light bulb. When electricity passes through it, it glows orange.

Auto White Balance

Auto White Balance (AWB) does a pretty good job most of the time, but I want to show you how AWB works via a colour wheel.

Imagine you're inside a restaurant lit by tungsten light bulbs – an orange light is being emitted. On Auto White Balance, the camera sees the orange light and adds the colour opposite to it on the colour wheel – in this case, blue – into the image in equal measure. The same amount of blue cancels out the orange and brings the light in the scene to white, as shown in the graphic to the right.

So, AWB balances the light as best as it can back to white.

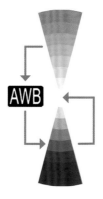

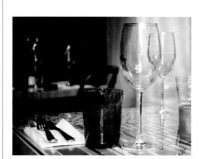

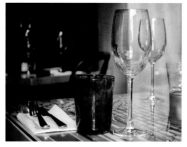

Opposite colours on the colour wheel will cancel each other out – this is how your camera's Auto White Balance setting works. Here's another example.

We start with a blank piece of paper – pure white.

Then I add a blue cast over the paper.

If I overlay the exact shade of orange that's opposite on the colour wheel…

…it cancels out the blue, making it grey. This is also called 'neutral density'.

Then, to make it pure white again, all you do is brighten it up. This is what your camera's AWB setting is doing.

So, what if you like the orange glow of the light bulb, or what if AWB is not doing a good job?

This can happen in situations where you have a mixture of light sources. This is where you take control and tell the camera what light source you are shooting under.

Look at the picture above of some light bulbs. This is the colour given on Auto White Balance. The oranges have been turned back to pure white as best they can.

To make sure the oranges turn white, set your camera's white balance to tungsten. The camera will then specifically look for tungsten light and turn it back to white.

If you want to show colours as true, set the camera's white balance to daylight. In this setting, the camera doesn't add any colour to your shot and shows the true colour of the light source.

White balance

Knowing about colour temperature can help you obscure or intensify the colour of your shots to get different effects.

Here's a picture of an alleyway with street lighting – the sun has just gone down. This picture has been balanced to tungsten light. You can see this because it's turned everything that would be orange, such as the street lights, to white.

The sky also looks a lot bluer than it would do normally and that's because the camera has added blue to the shot to cancel out the orange. There wasn't any orange in the sky to cancel out, which is why it looks bluer.

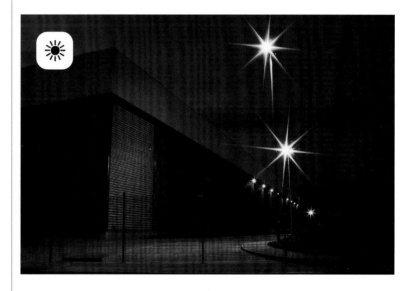

The picture above has been balanced to daylight – no colour has been added by the camera. This is giving you a true representation of what the street lights look like.

You can see that they are orange and you can see how the light hitting the concrete and factory building also has an orange glow.

Because the camera has been balanced to daylight, it is showing the realistic colours of the street lights.

If this was taken on AWB, the camera would have tried to turn these oranges back to white.

Task #23

Get familiar with white balance settings.

Here are some tasks to get you working around your white balance settings so you can see the different effects you can have on an image when you control the white balance.

Here's how to change the white balance on common cameras. Other cameras will be very similar, but refer to your camera's manual under 'white balance' if you get stuck.

Canon

- Put your camera onto P setting.
- Press the WB button. This will bring up the White balance menu.
- Select the white balance you want.

Nikon

- Put your camera onto P setting.
- Press the 🛈 button and go to the White balance setting.
- Select your white balance.
- Some Nikon cameras will have a WB button that you can press for easier access.

Task #24

Take pictures of the same scene in different white balance settings and answer the following:
What colour is being added to the scene?
What colour is being cancelled out from the scene?

1. Set your camera to P.
2. Put your ISO on Auto and make sure you've set image quality to JPEG.
3. Go outside and make sure there is some sunlight.
4. Take shots on different white balance settings and note the different colour cast that each picture has.
5. Make a note of what colour the camera has added to give that effect.

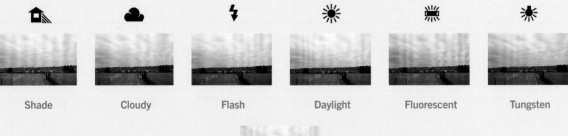

| Shade | Cloudy | Flash | Daylight | Fluorescent | Tungsten |

Auto White Balance

Task #25

Now practise your control of white balance.

Take shots of urban night scenes where you have different types of light sources. Adjust your white balance accordingly to enhance or cancel out colours to get a desired visual effect.

You will need to use a tripod and a remote trigger or cable release, or select your camera's 2-second timer to keep your camera still during the exposures.

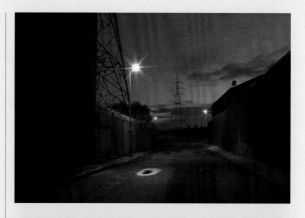

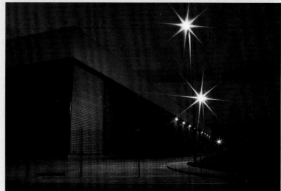

Let's recap on this chapter:
There are lots of different types of light sources: flash light, street light, light bulb etc. Knowing what effect they give a photograph will help you plan a good shoot.

- Light comes in many different colours. Your camera will try to turn those colours back to white if you leave it on Auto White Balance.

- In general, you get two different effects of light, one being hard, which is light coming directly from the source and hitting the object, and the other being soft, which comes in two different variations: reflected light and diffused light.

- White balance can be set on your camera. You use white balance to cancel out colours that you don't want. You can also set white balance to daylight to capture colours as they are.

I hope you enjoy these tasks. When you're ready, move on to the next chapter.

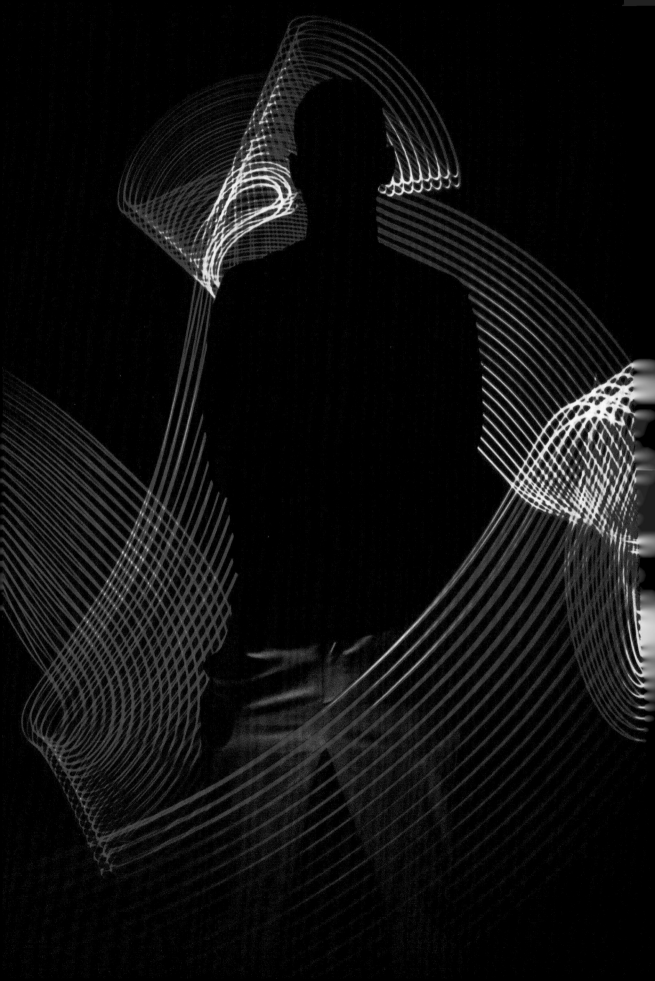

14

Painting with light

Painting with light

In this chapter, we are going to put together all of our knowledge and try a technique called light painting. This is a really fun task and cements what we've learned about controlling light. It's an extension task, but one you will really enjoy.

Before we start, I want you to look at the picture to the right and tell me how you think it's been created. Write down what you think the settings were, what equipment was used, and so on.

Think about all the knowledge learned from this book. How would you recreate this shot? Write an answer down and then read on.

I hope you have some good stuff written down.

I want you to look at this picture and do the same – how do you think it has been taken? Again, draw on the knowledge learned from this book.

OK, so, this is how they have been made. These are called long-exposure shots, these particular type are called light paintings, and to create these types of shots you have to work in fully manual mode and need to know how to balance light correctly.

They were taken as one long exposure, so this would have been around a 30-second shutter speed. Because you need to let light in slowly over a long period of time, the aperture would be small, around f/22, and the ISO would have been around 100. You also have to use a tripod so that everything stays still except the moving lights.

There are two people in this shot above – one you can see and one you can't. The person you can see was lit with a torch while standing still. The person you can't see is behind them and drawing the 'batwings' by waving an LED torch in the air. The reason you can't see the second person is because they were moving around and weren't lit by any light.

The second one (above) was a long-exposure shot but during the exposure a burst of flash has gone off to light the person's face. Then they have moved and another burst of flash has gone off. They move again, another burst of flash, and so on. You can also do this with a bright torch and just flash that on and off instead.

The reason you can only see the face and not the body is because no light hit the body – the light only hit the face.

You don't get shots like these right first time; you need to run through a few test shots first, figure out if you need more or less light, then adjust settings and techniques until you get the look you want. That's what makes it good practice and doing this task will really help you to understand how to take control of light.

So, to create shots like this, this is what you need:

- A small aperture
- A long exposure using the shutter speed
- Low ISO
- A tripod
- A bright torch and possibly a flash

Then experiment, get creative and have fun.

Task #26

Create light paintings.

It's best to go outside at night to do this, but you don't need to – you literally just need a dark room. It's important that wherever you do this, it's as dark as can be.

1. Put your camera on a tripod.
2. Set it to Manual mode (M).
3. Set your shutter speed to between 15 and 30 seconds (experiment for best results).
4. Set the aperture to f/22.
5. Set the ISO to 100.
6. As it's dark, your camera may not be able to focus on your subject. To solve this, use manual focus or light the subject with a torch and focus in on them.
7. During the exposure, use a torch to draw whatever you want or light whatever you want.
8. Then it's just a big experiment to get different effects!

Give this a go and have some fun with it.

As always, we would love to see your attempts at this. So, if you want to show us, tag your best shots on social media **#theschoolofphotography**

When do you photograph in full manual mode?
Well, it sounds obvious, but you photograph in full manual mode when you want to take full control of everything. It's normally when your camera's light meter can't figure out what your intentions are because you're getting creative, like with these light drawings.

Your camera hasn't got a clue what you're thinking when doing these types of shots so you have to take full control over the camera to get the desired shot.

If you just want to take control over the aperture and depth of field, you can use the A or Av setting. If you just want to control shutter speed, you can use the S or Tv setting. If you want full control of everything, you use fully manual and balance the light yourself.

Remember: ISO, apertures and shutter speed can be balanced in stops. Your job as a photographer is to get that balance right for your desired visual effect.

That's this section over with. When you're ready, move on to the next chapter.

15

Balancing exposures with flash

Fill-in flash

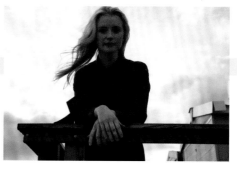

No flash

This section will expand on the balancing of exposures by introducing a technique called fill-in flash.

Fill-in flash is typically used to brighten areas of shadow when shooting outside on a sunny day. You might not think that you would need to use flash outdoors, but it really does help lift shadows caused by bright sunlight. And, by using fill-in flash creatively, you can control the darkness of your background.

Here is an example of fill-in flash. The picture top right was taken outside using the P setting on my camera. The picture above right was also taken on the P setting, but this time a flashgun was added to the camera.

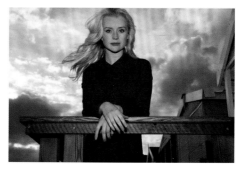

Fill-in flash

This is the simplest use of fill-in flash – you just add a flashgun or pop your flash up and shoot away while in Program mode. You can see how much brighter the flash has made the face – and it has filled in the shadow areas.

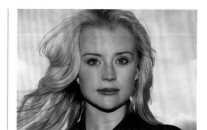

Fill-in flash lightens shadows

In this example (far right), I've underexposed the background to make it darker.

The flash exposure – that's the exposure of the person – is exactly the same in both images, but the background has been exposed differently.

You do this by combining your Exposure Compensation setting with your Flash Exposure Compensation setting.

Fill-in flash

Fill-in flash with ambient light underexposed by 2 stops

This technique can get a little complicated because what you're doing is thinking about two exposures at once. You're thinking about the flash exposure – the light hitting the subject – and your background exposure, which is called your 'ambient light' (the rest of the light in the scene – in our case, the daylight).

In chapter 7, we looked at exposure compensation. This is where you control the light coming into the camera to make a picture darker or lighter by holding down the +/– button and twisting the dial to -1, -2, etc.

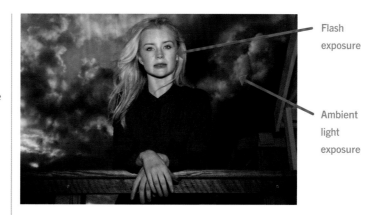

Flash exposure

Ambient light exposure

In the same way, this is how you control the exposure of your ambient light (your background light) while using fill-in flash. You then use something called flash exposure compensation to control the brightness of your

flash. The technique is this: you underexpose the background while keeping the person correctly exposed via the flash.

Task #27

Get familiar with the camera settings.

Here's how you use exposure compensation and flash exposure compensation on common cameras. Look up these functions in your camera's user manual if they are different.

Canon

- Set your camera to P mode.
- Press and hold the Exposure Compensation button and then twist the dial on the camera to -1, -2, etc. to darken the ambient light (highlighted yellow).

To change your flash exposure:
- Press the Q button.
- Go to the Flash Exposure Compensation setting (highlighted red) and press Set. Increase the flash power to +1, +2, etc. Press Set to confirm.

Nikon

- Set your camera to P mode. Press the ℹ button.
- In the menu, you'll find Exposure Compensation (highlighted yellow) and Flash Exposure Compensation (highlighted red).
- You can select either of these then press OK.
- Change the level up and down as required.

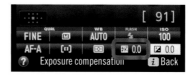

Task #28

Balance exposures with flash.

Things to note

If using your camera's pop-up flash, you can only use fill-in flash in close proximity to your subject. Your pop-up flash will only reach a couple of metres in front of you in bright sunlight.

However, if you're using a flashgun, you're going to get a longer range. Also, on most flashguns, you control the flash exposure compensation directly on the flashgun, not in the camera menu. Each flashgun works differently, so look up 'flash exposure compensation' in your flashgun manual for instructions on how to do this.

Go outside with a subject, preferably when it's sunny.

1. Put your camera on the P setting and set ISO to 100.
2. Take a shot of the model with the sun behind them and without flash.
3. Take another shot, but this time with your pop-up flash on or your flashgun on its default setting (called ETTL).
4. Then control the ambient light and the flash light to get different visual effects.
5. Going down to -1 and -2 on the ambient light will make your background darker.
6. Going up to +1 and +2 on your flash light will make your foreground brighter.

Take shots at different settings and compare the differences.

Above: **A flashgun will slot into the hotshoe of your camera.**

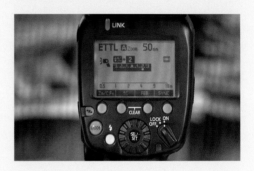

Above: **You access the flash settings on the back of the flashgun, not in the camera menu.**

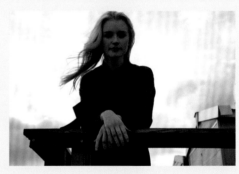

No flash

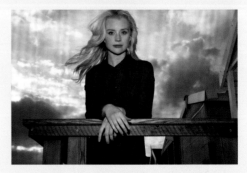

Fill-in flash

Fill-in flash

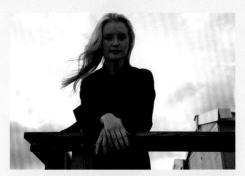

No flash

Fill-in flash

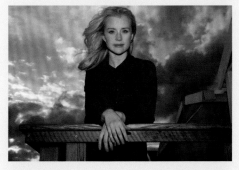

Fill-in flash — ambient light underexposed by 1 stop

Fill-in flash — ambient light underexposed by 2 stops

Flash overexposed by 1 stop — ambient light underexposed by 2 stops

Flash overexposed by 2 stops — ambient light underexposed by 2 stops

Fill-in flash recap

Let's recap on balancing exposures with fill-in flash:

- Fill-in flash is used to brighten areas of shadow when shooting on a sunny day.

- By using fill-in flash in conjunction with exposure compensation, you can control how dark the background is.
- You can only use fill-in flash in close proximity to your subject. This is dependent on the strength of your flash.
- You can use fill-in flash when shooting directly into the sun to give lens flare effects.
- It's a great technique, particularly for portraiture.

Enjoy experimenting with this technique and read on when you're ready.

16

Post-production & using Raw files

Working with Raw files

This chapter is about the post-processing of digital images and Raw files.

First, understand that every good image has been post-processed in some way. Even before digital photography, prints were enhanced. Skies were burned in to make the clouds clearer, foregrounds were dodged to make them brighter, faces were retouched to remove blemishes and so on.

Now we do a very similar thing with digital files and it's something you will need to learn.

However, it's important to remember that your first stage is learning and controlling photographic techniques. Only when you're confident with that should you learn about post-processing. Good post-

Examples of post-processing before digital photography

Above: **Mary Pickford, 1910.**

Left: **'The Tetons and the Snake River'**, Ansel Adams, 1942.

processing will rarely recover a badly taken shot.

Post-processing is what you do to a picture after you've taken it. These days, that's done in a computer program and there are several you can use to post-process images. You can get free programs on the internet, you can get apps on your phone, and you can get paid ones.

Free programs
There are a couple of free post-processing programs that are quite popular.

One is called **pixlr.com**. This is a good online photo manipulation tool, but it's web-based, meaning you use it through your internet browser and have to be online to use it.

Another free program is called **Gimp**. This one can be downloaded directly from the website gimp.org and you install it like you would any program.

Paid programs

Adobe Photoshop is a really powerful photo manipulation tool mainly used by professionals.

Adobe Photoshop Elements is a cheaper version. It's Adobe's entry-level package and is designed to give you a taster of the full program.

You can also get **Adobe Lightroom**. This program is not a photo manipulation tool like Photoshop. Instead, it's designed to assist you in managing large quantities of digital images. It is a digital darkroom and image management system that allows you to import, process and export a batch of files all at once. It's designed to work hand in hand with Photoshop. It's a really good package, especially when you start working with Raw files.

There's also another good program called **Affinity Photo** by a company called Serif. This is a good option, as it's a powerful program and cheaper than Photoshop.

In my examples, I'm going to use the two most popular programs – Photoshop and Lightroom – to show you how you can do a few simple things to make your images ten times better.

Raw files

Before we get into that, I want to talk about what Raw and JPEG files are and the differences between the two. These are the two main types of digital files that are produced when you take an image. You can either shoot in Raw or you can shoot in JPEG.

A Raw file preserves most of the information from the camera – it doesn't process or compress it. It's like an old negative (right), if you remember them. You can't actually see the image from a negative and this is the same for Raw files. A negative needs to be processed in a darkroom with an enlarger, paper and chemicals before you can see the image.

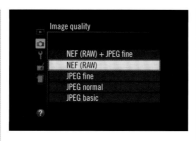

It's the same for a Raw file – you can't actually see the image until you process it through a computer program, which effectively becomes what used to be the darkroom.

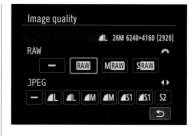

The Raw file is just holding the information needed to produce a print, like a negative.

JPEG files

A JPEG file is a visible image – you can see it on the screen, print it out and view it on any computer or device.

A JPEG is a compressed file. The camera takes the Raw data and compresses it into a code. That code is then read by computers and opened up into an image. You have moderate information in a JPEG file, but you don't have as much as you would with a Raw file. This means you can't push a JPEG as far in post-processing.

Let's say you want to make a JPEG image brighter. You will only be able to brighten it by 1 or possibly 1.5 stops before you start to see visible degrading in image quality.

Name	Type	Size
Original RAW file.dng	DNG File	25,472 KB
Processed Jpeg.jpg	JPG File	5,877 KB

On average, a Raw file is three to five times the size of a JPEG file. This is because there is a lot more information in Raw files, which is beneficial when you enhance them in digital programs.

Latitude of a JPEG file

| -3 stops | -2 stops | -1 stop | 0 stops | 1 stop | 2 stops | 3 stops |

Approx. 1.5 stops before severe degrading of image

You can push a Raw file 2 or possibly 3 stops. This is what's called the 'latitude' of the image.

You have much more latitude in a Raw file than a JPEG file.

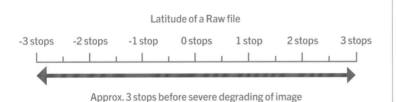

Latitude of a Raw file

| -3 stops | -2 stops | -1 stop | 0 stops | 1 stop | 2 stops | 3 stops |

Approx. 3 stops before severe degrading of image

When you're shooting in JPEG, your camera gives you a 'compressed' version of the Raw data. You will see this in the size differences between Raw and JPEG files.

Should you shoot in Raw or JPEG?

This is a question I get asked a lot. Well, you should shoot in Raw only if you know what to do with that file in post-processing. Also, if you don't know how to control your depth of field, ISO, composition, shutter speed and everything else you have learned throughout this book, then you need to stick to JPEG and get all that right first because all you will do is add another element of confusion to your learning process.

A Raw file won't get you a good image – your control of photography will do that.

Processing a Raw file in Lightroom

Here's an example of what you can do with a Raw file in post-processing.

I used Lightroom to take an image from its Raw state into

something much better with just a few steps.

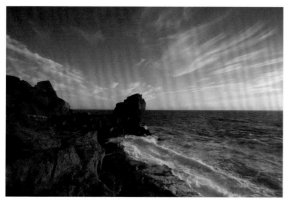

Orignal Raw file

Processed Raw file

1. First, I changed the colour profile to Adobe Landscape, as this is a landscape picture. This changes the colour saturation slightly, as you can see to the right.

Before

After

2. Next, I made some adjustments in the basic panel. I brightened the exposure, darkened the highlights, brightened the shadows and increased the saturation and vibrance.

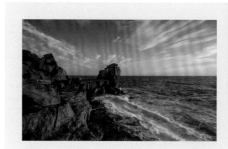

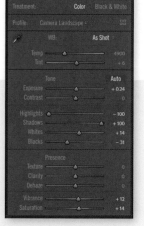

3. Next, I added a slight 'S' curve in the Tone Curve panel. This just increases the contrast slightly.

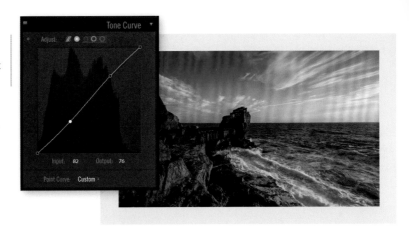

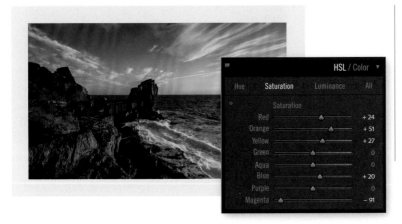

4. I adjusted the colours individually in the HSL/Color panel. I increased the saturation and luminance of the blues to bring out the sky more, and then I increased the saturation of the yellows, oranges and reds to bring out the sunset colours.

5. Then I sharpened the picture in the Detail panel. The first image doesn't look too bad, but every digital image needs to be sharpened in post-processing, so I put the Sharpening to 80 and the Radius to 1.2.

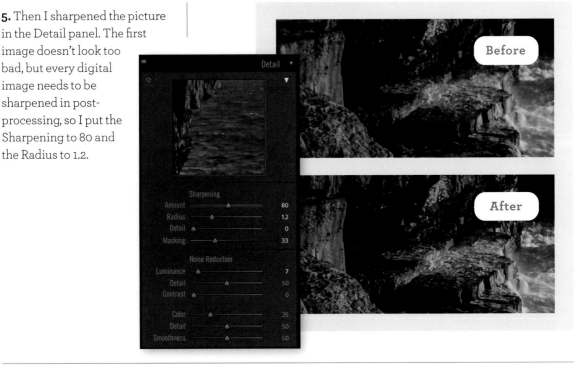

Processing a Raw file in Lightroom

6. If you look closely at the edges of objects, you will see there are two colour outlines: red and green. This is called 'chromatic aberration' and happens to some digital images (top right). In the Lens Corrections panel, I ticked Remove Chromatic Aberration. As you can see, it has reduced these coloured outlines (below right).

7. I then used the Crop Tool to improve the composition by having the clouds coming in from the top left of the frame.

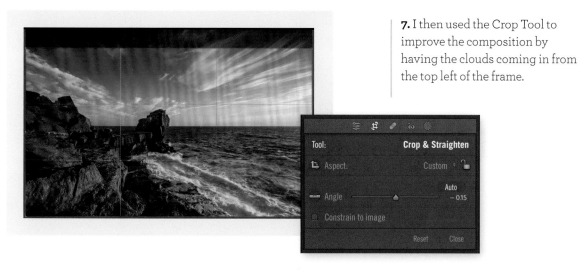

8. Finally, I added a slight vignette to the outside of the frame in the Effects panel.

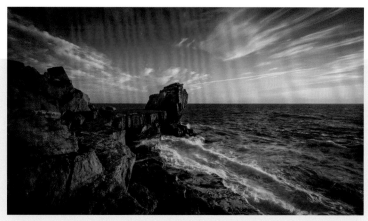

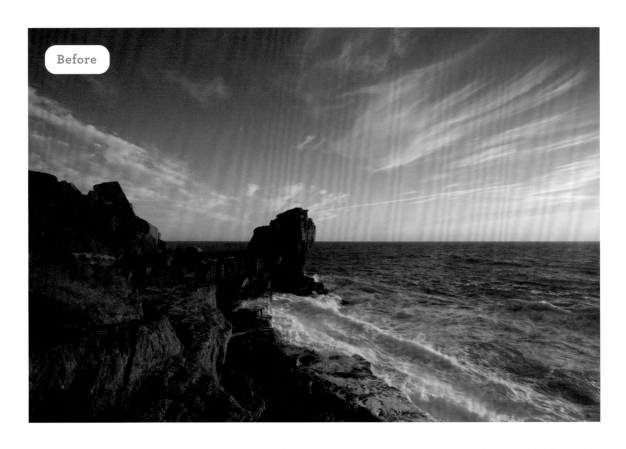

Before

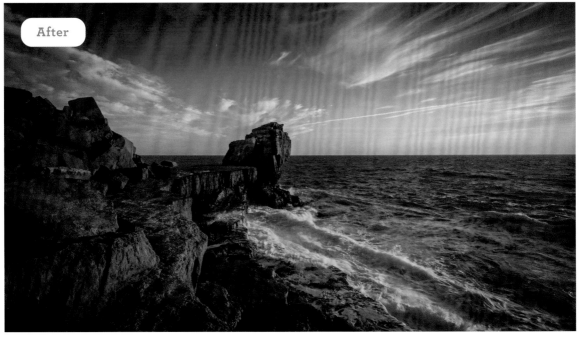

After

Processing a Raw file in Lightroom

Processing a JPEG in Photoshop

Original JPEG file

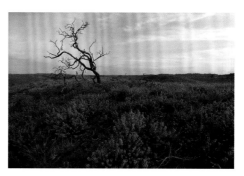

Processed JPEG file

Although it's better to use Raw files when post-processing, you can process JPEG files as well. I'm going to show you the same process, but this time I will use a JPEG and do it in Photoshop.

Before

After

1. The first thing I did was sharpen the image by going to Filter > Sharpen > Unsharp Mask. Then I used the same sharpening settings that I used in Lightroom: Amount 80, Radius 1.2.

2. Next, I added a Curves adjustment layer and gave it some contrast with a slight 'S' curve.

3. I then enhanced some colours using Curves adjustment layers. This allows you to target specific colours. For instance, you can choose a blue curve and enhance just the yellows and blues.

After

Above: **The image after Curves adjustments.**

4. I then added another Curves adjustment layer, but this time took the highlights down drastically to darken the image.

One of the benefits of Photoshop is that you can work on individual layers and then work on masks within that layer.

On the mask of my darkened layer, I removed the effect of the darkening from all parts of the image except the sky. I then adjusted the colour balance, which gave a rich, warm tone to the sunset.

Above: **Darkened with Curves adjustment layer.**

After

Above: **The final image with darkened areas removed using layers and masking.**

This is just a brief introduction to what Photoshop and Lightroom can do in the post-processing of your images. Learning to use these programs are totally new skills and this will be your next stage to becoming a great photographer. I recommend you learn Lightroom first, then Photoshop.

And, of course, we are The School of Photography, so we have courses to get you started in Lightroom and Photoshop. For more info on these courses, go to **www.theschoolofphotography. com** and click 'Online Courses'.

When you're comfortable with controlling photography, start shooting in Raw and learn about post-processing your images properly, as it really does make a good image great.

▶ To view video tutorials on post-processing, go to **www.theschoolofphotography. com** and type 'curves', 'Lightroom' or 'Photoshop' in the search bar.

17

End of book recap

What you've learned...

So, that's the end of _The School of Photography: Beginner's Course_ book.

There are two things I hope you got from it. One is that you learned a lot and are now on a path to taking better photos. The other is that you had fun doing it. It's very important to have fun while learning – it motivates you and pushes you to learn more.

■ First, we looked at camera kits and recommended equipment for when you're starting out in photography.

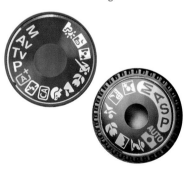

■ Then we explored manual settings – you'll never use automatic modes again!

■ Next, we focused on focusing and how to get your focus point exactly where you want it to be.

■ We then looked at composition – the way you arrange elements within your frame. Personally, I think it's one of the most important things to get right in any picture.

■ We also looked at lenses and focal lengths. You can use focal lengths to get a desired effect. Certain focal lengths will suit different situations. For example, a wide angle will suit landscapes and zoomed in will suit portraits. Don't zoom in and out just because you can't be bothered to move forwards or backwards!

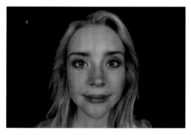
16mm

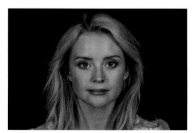
100mm

■ We delved into metering, how a camera measures light and how to override this by increasing or decreasing the light – or by taking meter readings from specific parts of the frame.

■ Then we looked at ISO: what it is, how it affects your exposure, how you can reduce noise and how you can make your camera more sensitive to light in low-light situations.

■ We also studied resolution and looked at why you would use high- and low-resolution images.

■ We explored light and how you can create hard, soft or diffused light, and how this affects an image.

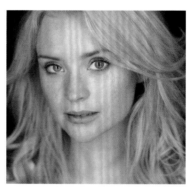

Soft light

Hard light

■ We then looked at colour temperature and how you can use your camera's white balance to enhance or cancel out certain colours.

■ We looked at exposure in photography, which is how much light you let into your camera. We practised our use of apertures and our control of depth of field. The three things that control depth of field are aperture, focal length and distance between your lens and focus point.

■ We explored shutter speed and worked through many different techniques. Shutter speed lets in light over a period of time and can be used to freeze the action or show a sense of movement.

■ Then we moved on to learn about balancing exposures via your aperture and shutter speed. It's that ability to balance light that makes you a photographer and not just someone who uses their camera on automatic. By balancing your exposure, you can let the same amount of light into your camera but create totally different visual effects.

f/8 – 1/2 second – ISO 400

f/1.4 – 1/60 second – ISO 400

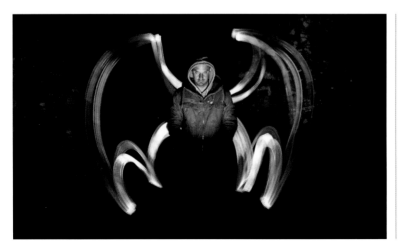

■ We practised working in full manual mode by creating light paintings. This is a great way to mix all of what you have learned and take control of photography.

What you've learned

■ Then we got even more advanced by balancing exposures with flash and, in particular, learned how to use fill-in flash to create different visual effects.

■ Finally, we looked at the post-production of shots and examined using Raw or JPEG files. I showed you some steps to enhance your photography using Adobe Lightroom and Photoshop. Working in Raw and post-processing your shots are the next stages in your learning.

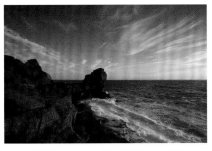

Original raw file

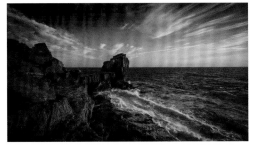

Processed raw file

Get social
I hope that this book has really helped you out, and I cannot wait to see some of your shots!

Don't forget, you can show us your best shots on social media. Tag **#theschoolofphotography**

Follow us on social media too. We have a wonderful learning community of photographers, just like you.

It's been an absolute pleasure teaching you and I hope to see you on future courses at The School of Photography.

@theschoolofphotography1

@theschoolofphotography1

/c/theschoolofphotography
#theschoolofphotography

INDEX

exposure
 and aperture 74
 balancing 99–109
 changing settings 20, 21
 metering 59–65
 overexposure 22, 60
 and shutter speed 74, 85
 underexposure 22, 60
 see also light
exposure compensation 63–4, 65,
 136, 137, 139

flash
 balancing exposures with
 135–8, 155
 fill-in 136–7, 139
 and ISO 70, 71
 light painting 133
 and shutter speed 95, 96
 slow sync 95
flash light 120, 121
flashguns 121, 136, 138
fluorescent lighting 122, 124, 125,
 127
focal lengths 51–8, 83, 152
 and depth of field 81, 83, 84
focus point
 and depth of field 78, 82, 83, 84
 and shutter speed 96, 97
focusing 23–9, 152
 Autofocus 24
 controlling focus point 24
 focus settings 25
 modes 26–9, 92
 shutter release button 24, 29
frame within a frame 41–2, 45, 47
full-frame cameras
 focal length 52, 54, 56, 57, 58
 sensor size 54, 55

hard light 122, 123, 129
horizon line 38

image quality 114–15
 JPEG files 114, 115, 117, 128
imagery 35
ISO settings 12, 28, 67–71, 83, 153

and aperture 75
balancing light 106, 108–9
light painting 133
and noise 68–9, 70, 71, 83, 108,
 109
and shutter speeds 86, 95, 97

JPEG files
 image quality 114, 115, 117, 128
 processing in Photoshop
 149–50

knowledge-building 21

landscapes
 depth of field 81
 Landscape mode 20
 lens and sensor size 56
 post-processing in Adobe
 Lightroom 145–8
layered learning 21, 29
leading lines technique 44, 45,
 47, 83
lenses 50
 cleaning kits 17
 and focal length 56–8
 lens hoods 17
 prime lenses 50
 zoom lenses 50, 52, 56
light 119–29, 153
 colours 121, 122
 white balance 124–9
 sources of 120–1
 types of 120–3
 see also exposure
light painting 131–4, 154
 long-exposure shots 133

Manual mode 20, 21
 Av or A (Aperture priority)
 20, 21, 134
 balancing light in 106–7
 light painting 133, 134
 manual focus 25
 P (Program mode) 20, 21
 S or Tv setting 20, 21, 86, 92,
 97
matrix (evaluative) metering 61,

62, 65
memory cards, spare 17
metering 59–65, 153
 balancing exposure 107
 exposure compensation 63–4,
 65
 modes 60–2, 65
Micro Four Thirds cameras
 focal length 56, 57, 58
 sensor size 54, 55
mirrorless (compact system)
 cameras 14, 15, 20
mistakes 8, 12, 45
motion blur 106, 107
moving images
 balancing exposure 102
 focusing 26
 and the rule of space 41, 47
 shutter speed 90, 90–1, 92, 93
 panning 92, 94–5

natural light 120
night scenes, white balance 129
Nikon
 aperture setting 75
 balancing exposures with
 flash 137
 balancing light 107
 exposure compensation 63,
 137
 focusing modes 25, 26, 27
 ISO settings 70
 metering settings 60
 resolution settings 115
 shutter speed settings 86, 92
 white balance 128
noise 68–9, 70, 71, 83
 balancing light 108, 109
notebooks 8

odds, rule of 38, 39, 45, 46
overexposure 22, 60

panning 92, 94–5
photography, defining 8–9
Portrait mode 20
portraiture
 camera and sensor size 56

CREDITS

Additional photo credits: 10b, 142b National Archives and Records Administration; 10c, 12a, 142a Library of Congress, Prints and Photographs Division; 11b George Eastman Museum via Wikimedia Commons; 11c Harry Ransom Research Center, University of Texas, via Wikimedia Commons

NOTES

About The School of Photography

At The School of Photography we deliver high-quality photography courses online, in person and in books, and are a leading provider of photography education to schools and colleges in the UK.

I'm Marc Newton and I run the team here. I'm a photographer, educational speaker, author and teacher of photography.

Teaching photography has been my passion for many years. I got my first paid photography job in 1997 while doing my photography degree, but in 2002 I decided to give teaching a go and haven't looked back since.

I loved seeing the stunning imagery my students produced.

It filled me with a real sense of joy, and still does today. My success in teaching led me to become an Advanced Skills Teacher and I started to train UK school teachers to deliver the GCSE and A Level Photography curriculum. I wanted to take all of this experience and offer it up to a wider audience, so in 2012 I started The School of Photography and now I teach this beautiful craft to people all over the world.

My qualifications are as follows:
- BA Honours degree in Photography.
- Postgraduate Certificate in Education (PGCE).
- Qualified teacher status (QTS).
- Advanced Skills Teacher (AST) in Photography.

Rest assured that you're in good hands. This is real learning delivered by professional teachers.

View my portfolio, exhibitions, awards and publications at **www.marcnewton.com**

Our courses
Visit our website to see our full range of online video courses, books and eBooks.

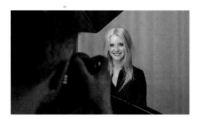

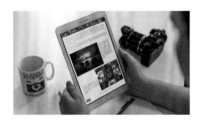

Visit **www.theschoolofphotography.com** to learn more!